IDENTITY DESIGN THAT WORKS

Secrets for Successful Identity Design

GLOUCESTER MASSACHUSETTS

ROCKPORT PUBLISHERS

Cheryl Dangel Cullen

First published in the United States of America by
Rockport Publishers, Inc.
33 Commercial Street
Gloucester, Massachusetts 01930-5089
Telephone: (978) 282-9590
Fax: (978) 283-2742
www.rockpub.com

Library of Congress Cataloging-in-Publication Data
Cullen, Cheryl Dangel
 Identity design that works : secret for successful identity design/
Cheryl Dangel Cullen.
 p. cm.
 ISBN 1-56496-950-9(pbk.)
 1. Corporate image 2. Industrial design Coordination 3.
Trademarks 4. Logos (Symbols) I. Title.
 HD59.2.C84 2003
 659.2-dc21 2002153666

ISBN 1-56496-950-9

10 9 8 7 6 5 4 3 2 1

Design: Laura Herrmann Design

Cover Image: Bobbie Bush Photography,
www.bobbiebush.com

Printed in China

dedication

To my mom, who has always encouraged me—especially through the incredibly turbulent times. I love and admire you.

acknowledgments

A special thanks to all the designers featured in this book whom I've gotten to know. Your work inspires me, and your friendship makes the work a joy.

indulge

refresh

relax

relax

indulge

refresh

www.departurespa.com

d_parture
spa

contents

Introduction

"Thingamajig." "Whatchamacallit." "Oh, you know the one."

Sometimes we take for granted what we call things and how we recognize them. But, for a moment, imagine the world without the identities we create for things that make them distinct and memorable.

Chances are you can't.

Identities fill such a basic human need that it is hard to imagine how we would get along without them. The human mind seems to come preinstalled with an operating system that uses distinct, easily recognized files to hold all the bits of information and experience we collect. Over time, some of those files become more familiar and valuable, but our minds appear to have a nearly infinite ability to create, update, and organize thousands and thousands of such files.

Enter the role of the designer.

Some of the most indelible images in our society are the identities crafted by designers. My son has been able to identify McDonald's by its arches since the time he started preschool. I've seen a colleague identify a small Starbucks sign from over 100 yards away on an airport concourse. And I know, without seeing any logo, what that Coke-red truck is carrying. Each of these examples show how basic components of an identity system are the cornerstone of branding—the cornerstones for creating what the Harvard Business School defines as "that for which the consumer believes there is no substitute."

Identity is an act of creation that is both obvious and obscure. Obvious because almost all of us have a natural instinct to create identities—that is, after all, how our minds work. It is fun to daydream about what we would call the business we might start, to doodle what its logo would be, and where it would sit on the letterhead. And yet, so much of what actually makes identities work is obscure. Designers must obsess over details that make identity systems distinct, appropriate, and applicable to all of a company's needs. Some aspects—like a logomark or logotype—are readily apparent, but underneath the surface are often painstakingly thought-out systems. These systems are what help extend a company's identity to almost every point where there is contact or communication.

When identity really works, a company is distinguishable, familiar, more valuable and—perhaps most important of all—has its own highly distinct file in our minds, full of our positive perceptions and experiences. And that sure beats "thingamajig," "whatsamabob," or "you know the one."

— **Tod Martin, President, EAI, Atlanta, Georgia**

Retail

Selling a product is so black and white—or at least, there are those who believe this is true. They'll tell you that a product is a tangible thing that can be photographed, displayed, demonstrated, touched, and felt by consumers, all of which makes for a much easier sales pitch than selling services.

This is all true; products sold at retail are concrete things that we, as consumers, must have. The trick is creating that "must have" desire.

Why would we want to purchase one pair of jeans over another? What makes an expensive bar of soap more desirable than a cheaper drugstore brand? Paints are all the same, right? Then, what makes us choose one brand and not another? Is it price?

We do our best to answer these questions in the following pages, as we track the launch of such diverse products as Levi's 501 jeans, a luxury soap, interior and exterior paints, auto and bicycle parts, to home and office products and furniture. Each of these manufacturers competes in markets that are flooded with similar products. What sets them apart from the rest? What differentiates their products on store shelves? What makes the consumer reach for their product and not the competitor's? What makes the consumer part with their money in return for a product?

Many times it all comes back to that "must have" mentality. Creating a feeling among buyers that this is indeed a product they cannot live without. The visual persona of a product contributes greatly to that allure. How much it plays a role in winning over the consumer is hard to measure, but the product's name and its graphics, whether it be on its packaging, advertising, point-of-sale materials, or signage, undoubtedly make that all-important first impression.

The visual identity is what gets consumers in the door. After that, the rest of the sale is up to the product.

Baronet:
When a Chair Is More than a Chair

DESIGN FIRM:
Paprika Communications

ART DIRECTOR:
Louis Gagnon

DESIGNERS:
Louis Gagnon, Francis
Turgeon, Bob Beck,
Isabelle D'Astous,
Annabelle Racine

ILLUSTRATOR:
François LeClerc

PHOTOGRAPHERS:
Michel Touchette,
William Jarrett

CLIENT:
Baronet Inc.

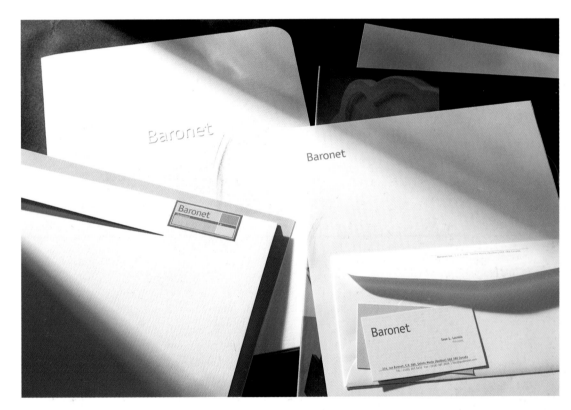

The Process

When Baronet Corporation, a furniture manufacturer,
retained Paprika Communications to develop a comprehen-
sive branding corporation, the plan was to be executed in
three phases. Phase one consisted of designing and produc-
ing a complete product catalogue intended for both retailers
and consumers. Next, designers were to develop a special-
ized magazine campaign to promote the Baronet brand to
the trade and consumers, as well as to create a series of
store posters for the largest North American retailers that set
up a Baronet boutique space inside their sales outlets.
Finally, phase three consisted of designing the permanent
Baronet showroom located in High Point, North Carolina.

ABOVE: **The Baronet
logo as it appears on
its letterhead system.**

BELOW: A Baronet brochure showing many moods of Baronet.

The obvious major challenge for Paprika Communications was how to strengthen Baronet's visibility among all of its audiences using a single visual communication package that would work in North America and Europe within the budget allowed. They had to reinforce the Baronet brand as an industry leader that strives to go beyond mere furniture manufacturing and, instead, invests in designing new collections so that it maintains its position at the top of its industry and to communicate that message to retailers and consumers.

Designers credit their success in reaching all the objectives by limiting the number of communications tools they developed to a comprehensive catalog, a magazine advertising campaign, a store poster promotion, and design of Baronet's showroom in North Carolina.

The Baronet catalogue consists of a series of ten brochures highlighting different furniture collections. It is assembled in a handsome black, embossed binder, and the brochures are each separated with a sheet of acetate. "The products are presented using location shots to seduce and studio shots for the technical information," says Joanne Lefebvre, president, Paprika Communications. Designers opted to go with a series of individual brochures as opposed to a full catalogue to avoid wasting resources and, by doing so, to distribute the catalogs to markets on a case-by-case basis. The design of the catalogue enabled retailers to procure and distribute individual collection brochures to a very targeted clientele.

RIGHT: Baronet's color book is also upscale and features diecuts.

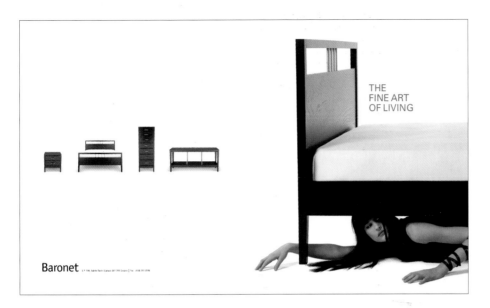

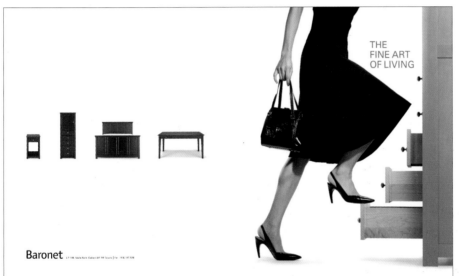

THIS PAGE: This series of ads appeared in selected upscale interior design and décor magazines made a big hit with their minimalist design and black, white, and gray color palette.

The magazine campaign consists of a series of four two-page spread ads published exclusively in magazines devoted to interior design and décor. Only prestigious, specialized magazines were chosen for the campaign, effectively pinpointing the focus and capping media spending. "In the end, the magazine campaign contributed substantially to promoting the Baronet brand and establishing its renown," says Lefebvre.

To maximize their design work, designers used these ads as the basis for an in-store poster campaign. They modified the ads slightly and reproduced some on paper, while others were put on styrene for light box projection—which gave retailers added flexibility. Moreover, the styrene helped convince retailers to keep the posters in the stores for the entire year. Most important, the store poster campaign bridged the gap between the magazine campaign and the in-store communication and unified the program.

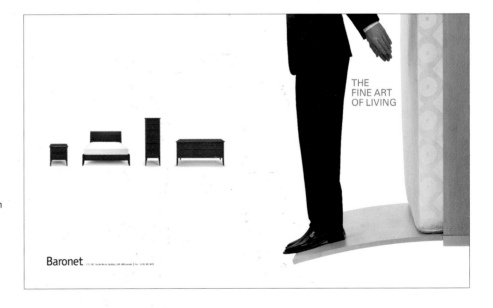

LEFT AND BELOW: Signage at Baronet's High Point, North Carolina, headquarters is sleek, rich, and elegant. Moreover, the diecutting that distinguishes its brochure is also carried into the showroom's interior décor, where signage and interior walls feature translucent panels with the same pattern.

"The design of the High Point showroom is the meeting point of all the visual components designed and helps us set the Baronet personality in the mind of the buyers and consumers," says Lefebvre.

"In the image of the Baronet Corporation's philosophy, the concepts proposed helped significantly to emphasize the value of the products. We presented them in a refined setting, classical and contemporary at the same time; sometimes by emphasizing a manufacturing detail—glass tray, marriage of wood and metal, etc. —as a whole, it is intended to be seamless, inseparable in order to communicate a philosophy, to create a distinct impression, a personality, an image: the Baronet brand," Lefebvre says

LEFT: This poster is displayed on a light box at the High Point showroom. The design is classic and artful, in keeping with the theme of the campaign, The Fine Art of Living.

RIGHT: Baronet's Web site features the same clean, white, minimalist design as its ads, signage, and letterhead system.

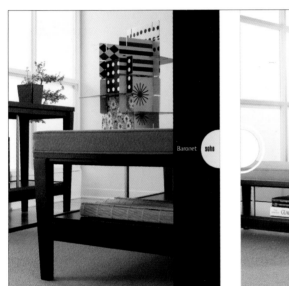

What Works

"Just like our client, we strongly believe the need to transcend the product. More than simple utilitarian objects, furniture is part of people's lives. Furniture is part of fashions, thought trends, a way of living. Furniture inspires a feeling of serenity, of chaos, etc. They furnish the home and the spirit," explains Lefebvre.

"The Baronet branding program contributed significantly to defining and communicating the Baronet brand. The firm's only sustainable competitive advantage, the Baronet brand, now has visibility beyond its product category. The Baronet brand leaves a distinct feeling resulting from the sum of what its product delivers. It now exists in the minds of its interlocutors. It has taken possession of an area in the mind of its target clienteles."

Over the last two years, Baronet experienced a more than 30 percent increase in its sales rate, which necessitated expanding two of its factories. "Moreover, Baronet benefited from wide press coverage in both Quebec and North America, especially from the many prizes won during design competitions such as Communication Arts, Applied Arts, and the Art Directors Club. Baronet has also been the subject of Canadian television news reports and was featured by *Émission D*, devoted to design throughout the world.

"This year, Baronet products made the front page of many special inserts in major dailies; several products were selected as being household 'must-haves' by very popular American design magazines," says Lefebvre.

ABOVE: Ten brochures featuring different collections, like this one for the Soho collection, were housed in the primary catalog/binder. Each brochure was eight to twelve pages long and was printed on 6-point satin finish paper and Italian stitched for insertion into the binder.

Bradford Soap Works:
An Identity That Comes Clean

DESIGN FIRM:
Weymouth Design

ART DIRECTOR:
Tom Laidlaw

DESIGNERS:
Brad Lewthwait

**WEB SITE
DESIGNER:**
Chris Geiser

PHOTOGRAPHER:
Michael Weymouth

CLIENT:
Bradford Soap
Works, Inc.

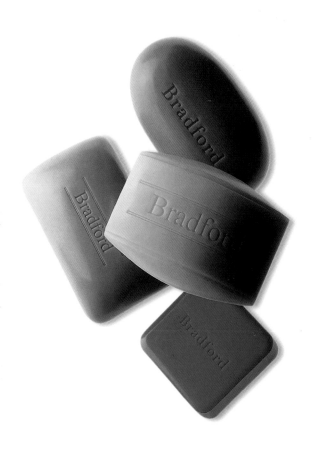

The Process

The Bradford Soap Works, Inc. head-quartered in Providence, Rhode Island, and in Chester, England, approached Boston's Weymouth Design for a new look. Its identity was suffering from a dismal lack of distinction. Marketing materials proclaimed that the original Bradford Soap Works provided "excellence in soapmaking since 1876," but the look that message was getting drowned out by an old, musty image.

"The old identity was dated and didn't appeal to the upscale audience that makes up Bradford's market," says Tom Laidlaw, art director, citing his client's original logo that featured a capital *B* in a stylized circle alongside the company name, Bradford, which was also reproduced in capital letters. "We needed to appeal to a more fashion-savvy audience [accustomed] to the Body Shop and other designer label distributors."

Bradford Soap Works is a specialty soapmaker that manufactures soaps for retail stores to sell. Consequently, it needed an identity that would not only win over consumers, but retailers who are very discriminating about sacrificing their precious shelf and floor space. With that in mind, Weymouth Design set about the job of updating Bradford's logo. The capital *B* was prominent in the original logo, so they retained that concept, but gave it a complete overhaul by filling the letter *B* with orange dots, not unlike the shape of Bradford's many soaps, for an abstract effect. It is coupled with the company name, which was reset in a more contemporary typeface.

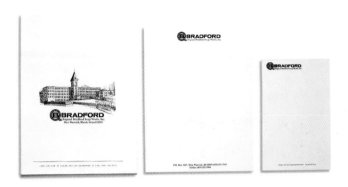

LEFT: The original folder featured the Bradford logo below a pen-and-ink illustration of its Rhode Island headquarters, a look that definitely dated the materials, making the company look stodgy and behind the times instead of the quality soapmaker that it was.

In retrospect, designers say that this logo is the single most important element in the identity as they used it as a major design element on a number of pieces that they created. For instance, when designers tackled the company's information folder, gone was the pen-and-ink illustration of Bradford's Rhode Island headquarters from the old identity. This was replaced with the new logo. The same approach was taken with the business card. Interestingly, designers set the *B* apart from contact information on the letterhead, mailing label, and large and small envelopes, which gives the icon even more impact and stand-alone strength.

Next, Weymouth translated the identity to the company's product—engraving the name Bradford on its soaps using the new type style. Designers suggested that Bradford send out sample packages of soaps and designed a black mailing carton for the job and wrapped in soap in specially designed tissue paper.

ABOVE: The single most important element of the redesign, according to designers, was the new logo—which is a capital *B*, in keeping with the old identity, but this time, it is contemporary and abstract, filled with orange dots that mirror the shape of Bradford's product.

LEFT: This invitation to a New York trade show invited prospects to see what's new at the Bradford Soap Works.

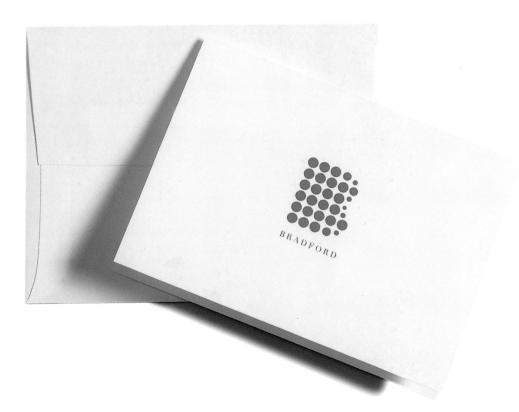

Designers also updated the company's brochure, creating a very clean cover using a photo of four different Bradford soaps against a clean, white background. Interior spreads are vibrant and show off what the company does best—provide excellence in soapmaking. The copy discussed how the science of soapmaking translates to art, passion, and perfection—the perfect message for an upscale retail audience who isn't interested so much in buying the soaps to get clean as they are for their beauty and fragrance.

Anticipating plenty of retail sales, Weymouth also created point-of-purchase materials including a bag with coordinating tissue, which repeats the dot pattern of the logo along with a series of posters that replay the theme of "science equals art, passion, and perfection."

Rounding out the identity makeover was a new Web site, www.bradfordsoap.com, advertisements, direct mail, a video, and a press campaign. Regardless of the application, the graphics associated with the identity are all in line with the upscale feeling of the logo.

"The clean and simple graphics stand out in a world of clutter and uninspired imagery," says Laidlaw. "The company's market is high-end cosmetic manufacturers. The identity needed to be high end as well."

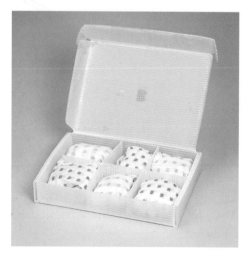 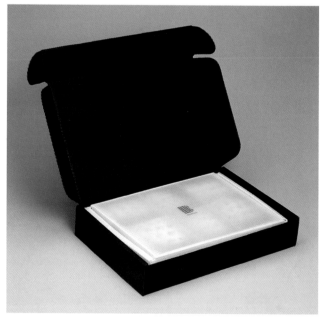

ABOVE AND RIGHT: A sampling of Bradford's variety of soaps was sent out to prospective retailers in a sturdy, yet elegant, black box. Soaps were wrapped in custom-designed tissue and the Bradford name was engraved in the soaps in its new typestyle.

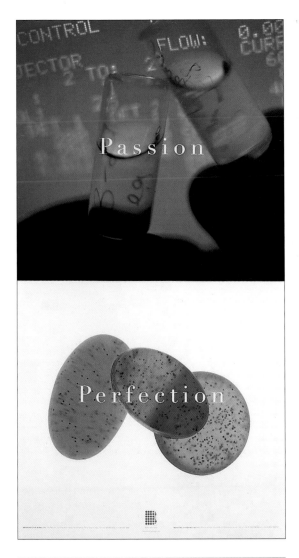

Passion

Vision

Perfection

Value

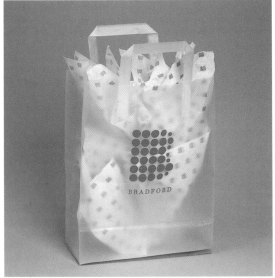

What Works

The new identity was unveiled at a trade show in New York City in June of 2001. Within six months, there were feature articles in four of the major trade magazines, including *Women's Wear Daily*.

"It's fresh, new and bold in comparison to Bradford's competitors," says Laidlaw. Moreover, it is versatile, he says. "It applies easily to ads, packaging, posters, signage, etc. The new identity is successful because of its strict adherence to usage guidelines and myriad applications have gotten the branding message out, loud and clear."

Chromos:
Painting an Identity

DESIGN FIRM:
Likovni Studio D.O.O.

ART DIRECTOR:
Tomislav Mrcic

DESIGNER:
Mladen Balog

ILLUSTRATOR:
Danko Jaksic

CLIENT:
Chromos

ABOVE AND OPPOSITE TOP:
Billboard and transit advertising is colorful, in keeping with the product line, and simple since it uses basic elements, such as paint tools and brushes —as identifying icons.

The Process

Chromos was been the leading manufacturer of paints and varnishes in the former Yugoslav market since the 1930s. However, due to the war, economic transition, and the disappearance of the Common Eastern European market, it has lost its position; when it approached Likovni Studio to help reinvigorate its sales position, Chromos sold product just in the Croatian, Slovenian, and partially Bosnian market, which represents only about 40 percent of the prewar Yugoslav market. This drastic loss of market share demanded swift attention, and the time was right for a new corporate identity and package redesign.

Likovni Studio was asked to remake the company's logo, which had been redesigned just a few years prior by another design firm. Chromos also had a mascot that had been in use since the late 1950s; it was well known and communicated tradition, but neither the previous logo nor the mascot was to be referenced in the new design. Instead, Likovni Studio was chartered with communicating Chromos' high-quality products by introducing new elements that would refresh the long existing brands and unite them in a corporate style.

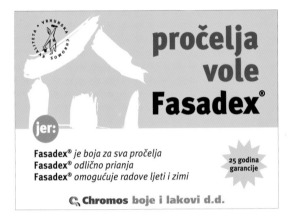

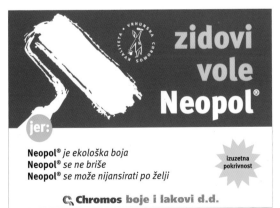

For years, the company had marketed solely to large corporations, including shipyards and big industry, so packaging and design weren't necessarily a priority. "The last redesign was done twenty years ago and it was done in a uniform way—all containers were designed to look the same, just wearing different brand names, which was appropriate to the current strategy," says Tomislav Mrcic, art director on the project.

Now, however, designers had to create an identity that not only reflected the company's move to attracting the young, do-it-yourself consumer market, but they couldn't risk alienating the professionals.

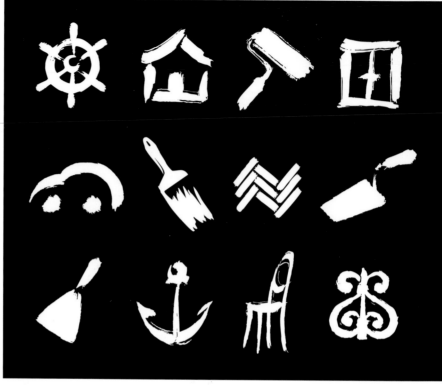

"Following the objectives, we kept the serious, legible, and quite classical layout and typography [of the previous identity and] combined [it] with powerful calligraphic styled graphics and bright colors. Simplicity makes it successful. Like one design critic has said about our work—'eloquent minimalism,'" Mrcic explains. "We based the new identity primarily on a strong graphic for it communicates faster and without words."

"The new corporate identity is based upon a radical packaging redesign totaling about 180 items and introduced pictographic images showing paint, tools, and objects," says Mrcic. "The vast number of registered trademarks was reduced to a few dozen and four of them were pushed as leading brands, according to the basic paint types—paints for metal, wood, interiors, and exteriors."

In keeping with Chromos's product line, all the basic colors were used and, despite the fact that a brush is the basic painting tool, a calligraphic approach was taken with the design. "To strengthen the impact of the brands on the shelves, we standardized typography for all brands by using Meta type family in all cuts including the Cyrillic alphabet for the Macedonia and Yugoslav markets," Mrcic says. "While more or less all of the paint manufacturers are using paradigmatic tools and objects, their packaging design is not so consistent through all the product lines and, of course, is weaker in building the institutional identity."

RIGHT AND OPPOSITE: For
the first time in its history,
Chromos was marketing to
the young, do-it-yourself
consumer instead of focus-
ing solely on large corpora-
tions such as shipyards and
industry. The design had to
appeal to consumers without
alienating its professional
customer base. Design was
more important than ever, as
was packaging, so designers
created notepads, shopping
bags, and T-shirts that
would appeal to consumers
and professionals alike.

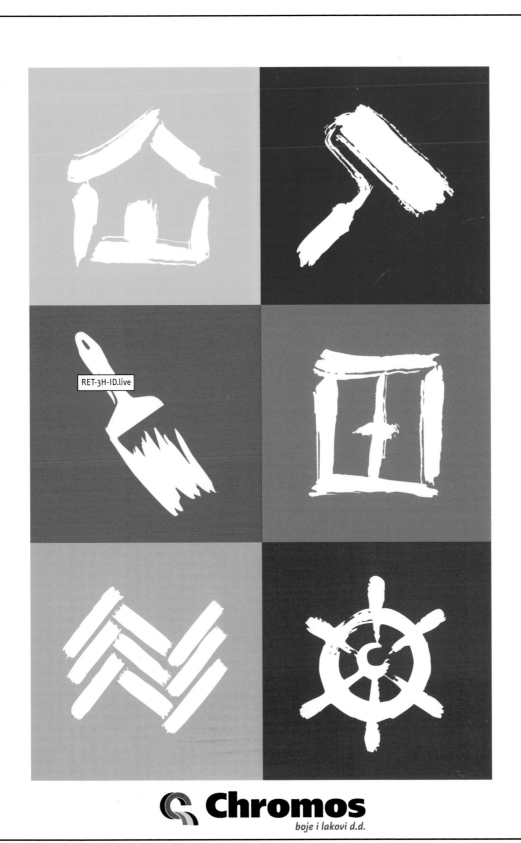

Chromos
boje i lakovi d.d.

Zagreb

Autolak

HR **Naputak:** Nanosi se štrcanjem u dva sloja sistemom "mokro na mokro"
BIH ili s međuslojnim intervalom od 24 sata. Prije uporabe lak dobro promiješati
te razrijediti **AUTOLAK RAZRJEĐIVAČEM.**
Utrošak: 7,0 - 9,0 m²/l u jednom sloju.
Uskladištenje: 5 godina u tvornički zatvorenoj ambalaži, u suhim i zračnim
prostorijama na temperaturi od +5°C do +25°C.

SLO **Navodilo:** Nanaša se z brizganjem v dveh slojih po sistemu "mokro na
mokro" ali z medslojnim intervalom po 24 urah. Pred uporabo lak dobro
zmešamo in razredčimo z **AUTOLAK RAZRJEĐIVAČ.**
Izdatnost: 7,0 - 9,0 m²/l v enem sloju.
Skladiščenje: 5 let v tovarniško zaprti embalaži v suhih in zračnih prostorih
na temperaturi od +5°C do +25°C.

ZAGREB AUTOLAK: završni lak u reparaturnom sustavu lakiranja
automobila i ostalih vozila / zaključni lak za lakiranje
avtomobilov in ostalih vozil.
ADR/RID 3. 31° C 30/UN1263 HRN.Z.CO.007 I.C **1 l**

R10	Zapaljivo / Vnetljivo.
R20/21	Štetno ako se udiše i u dodiru s kožom / Zdravju škodljivo pri vdihavanju in v stiku s kožo.
S2	Držati izvan dohvata djece / Hraniti izven dosega otrok.
S13	Čuvati odvojeno od hrane, pića i stočne hrane / Hraniti ločeno od hrane, pijače in krmil.
S23	Ne udisati plin/pare/aerosol / Ne vdihavati plina/hlapov/meglice.
S24	Spriječiti dodir s kožom / Preprečiti stik s kožo.
S43	Za gašenje požara koristiti aparat s prahom / Za gašenje uporabiti aparat s prahom.
S46	Ako se proguta hitno zatražiti savjet liječnika i pokazati naljepnicu ili spremnik / Če pride do zaužitja, takoj poiskati zdravniško pomoč in pokazati embalažo ali etiketo.
S51	Koristiti samo u dobro prozračenim prostorijama / Uporabljati le v dobro prezračevanih prostorih.

Xn

ŠTETNO
ZDRAVLJU ŠKODLJIVO

UVOZNIK: **SLO** Chromos d.o.o., Miklošićeva 20, Ljubljana, T 01 23 12 849
BIH Astra Dubravka d.j.o., Kneza Višeslava 12, Mostar, T 036 321 004

1 l
7-9 m²

Chromos

Chromos boje i lakovi d.d., Žitnjak bb, HR-10000 Zagreb
T 385 (0)1 24 10 666, www.chromos.org

Pirosil®

Temperaturno otporna boja za zaštitu metalnih površina
Temperaturno odporna barva za zaščito kovinskih površin

HR **Naputak:** Nanosi se kistom, valjkom i štrcanjem u jednom sloju.
BIH **PIROSIL** crni razrjeđuje se **CHROMODEN RAZRJEĐIVAČEM,** a **PIROSIL**
srebrni **RAZRJEĐIVAČEM 2.** Kod zahtjevnijih sustava zaštite pridržavati
se tehničkih informacija proizvođača. **Utrošak:** oko 0,08 l/m² u jednom
sloju. **Uskladištenje:** 24 mjeseca u tvornički zatvorenoj ambalaži, u
suhim i zračnim prostorijama na temperaturi od +5°C do +25°C.

SLO **Navodilo:** Nanaša se s čopičem, valjčkom ali brizganjem v enem sloju.
PIROSIL črni se redči s **CHROMODEN RAZRJEĐIVAČ,** a **PIROSIL** srebrni
z **RAZRJEĐIVAČ 2.** Pri zahtevnih sistemih zaščite upoštevajte tehnična
navodila proizvajalca. **Izdatnost:** oko 0,08 l/m² v enem sloju.
Skladiščenje: 24 mesecev v tovarniško zaprti embalaži, v suhih in
zračnih prostorih na temperaturi od +5°C do +25°C.

PIROSIL: temperaturno otporna boja (do 600°C) za zaštitu metalnih
površina / temperaturno odporna barva (do 600°C) za zaščito
kovinskih površin.
ADR/RID 3. 5° b 33/UN1263 HRN.Z.CO.007 I.B **0,75l**
sadrži / vsebuje: ksilen /ksilen

R10	Zapaljivo / Vnetljivo.
R20/21	Štetno ako se udiše i u dodiru s kožom / Zdravju škodljivo pri vdihavanju in v stiku s kožo.
R38	Nadražuje kožu / Draži kožo.
S2	Držati izvan dohvata djece / Hraniti izven dosega otrok.
S7	Čuvati u dobro zatvorenim spremnicima / Hraniti v tesno zaprti posodi.
S13	Čuvati odvojeno od hrane, pića i stočne hrane / Hraniti ločeno od hrane, pijače in krmil.
S24	Spriječiti dodir s kožom/ Preprečiti stik s kožo.
S43	Za gašenje požara koristiti aparat s prahom / Za gašenje uporabiti aparat s prahom.
S46	Ako se proguta hitno zatražiti savjet liječnika i pokazati naljepnicu ili spremnik / Če pride do zaužitja, takoj poiskati zdravniško pomoč in pokazati embalažo ali etiketo.

Xn

ŠTETNO
ZDRAVJU ŠKODLJIVO

UVOZNIK: **SLO** Chromos d.o.o., Miklošićeva 20, Ljubljana, T 01 23 12 849
BIH Astra Dubravka d.j.o., Kneza Višeslava 12, Mostar, T 036 321 004

0,75l
9,4 m²

Chromos

Chromos boje i lakovi d.d., Žitnjak bb, HR-10000 Zagreb
T 385 (0)1 24 10 666, www.chromos.org

Firnis
laneni

Firnis
laneni

Uporaba
Razrijeđen s **CHROMOS SINTETSKIM
RAZRJEĐIVAČEM** u omjeru 1:1
upotrebljava se za impregniranje
građevine stolarije i drugih predmeta od
drva (ograde, lamperija i sl.).
Nerazrijeđen se upotrebljava za korekciju
gustoće uljnih kitova za drvo.

Uskladištenje
24 mjeseca u tvornički zatvorenoj
ambalaži, u suhim i zračnim prostorijama
na temperaturi od +5°C do +25°C.

ADR/RID n.a.
HRN.Z.CO.007 II.B

1 l

Chromos

Chromos boje i lakovi d.d., Žitnjak bb, HR-10000 Zagreb
T 385 (0)1 24 10 666, www.chromos.org

Petrolej
za rasvjetu

Petrolej
za rasvjetu

Uskladištenje
Neograničeno u tvornički zatvorenoj
ambalaži, u suhim i zračnim prostorijama
na temperaturi od +5°C do +25°C.

ADR/RID n.a.
HRN.Z.CO.007 III.A

X7	Čuvati u dobro zatvorenim spremnicima
S15	Čuvati od topline
S21	Pri rukovanju ne pušiti

1 l

Chromos

Chromos boje i lakovi d.d., Žitnjak bb, HR-10000 Zagreb
T 385 (0)1 24 10 666, www.chromos.org

THIS PAGE: Product packaging
takes on an array of looks and
colors—while maintaining the
overall identity—depending on
the product and its usage.

What Works

"In this era of high technology, a high-tech approach is something that undoubt-
edly and unpretendingly attracts the target group, especially hobbyists who, at
first glance, recognize their life philosophy, but at the same time, not pushing
professionals aside," says Mrcic. "Painting is high touch by default."

Designers say that while it is still too early to measure the results, first reports
from the market show that sales of Chromos products have increased about 30
percent since the redesign debuted.

Halfords:
Auto and Bike Parts with Class

STUDIO:
Lippa Pearce Design

ART DIRECTOR:
Harry Pearce

DESIGNERS:
Harry Pearce, Jeremy Roots

PHOTOGRAPHER:
Richard Foster

CLIENT:
Halfords Ltd.

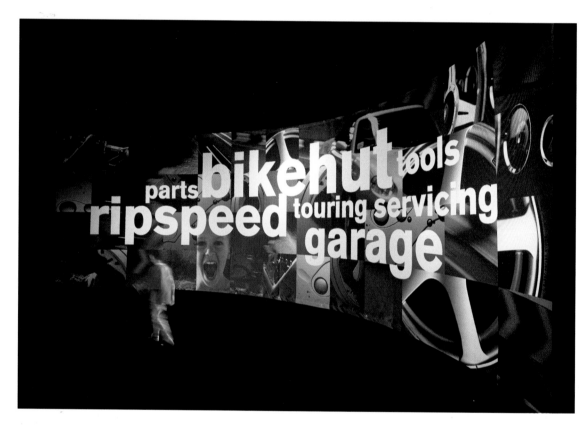

ABOVE: This gauze frieze runs around the exterior of Halfords's large retail stores. Designed in a monochrome palette, the result combines product- and emotion-driven imagery.

The Process

Despite the fact that both cars and cycles are hot commodities these days, Halfords, Britain's leading retailer of parts and services for cars and bicycles, was suffering from a tired image. Its identity, revolving around a color palette of pale blue, red, and gray, needed reenergizing.

"The goal was to modernize a tired set of basic elements and applications that were not reflecting the enormous advances Halfords had made over recent years," says Harry Pearce, art director, Lippa Pearce, which took on the project. "Halfords had become a company to embrace adventure and this had to be reflected in the new design."

Designers began by replacing the original color scheme with a new color palette of bright orange, yellow, and black, which, they say, "reflects the changing and the new face of Halfords and their increasing established presence in the industry as UK's leading auto and cycle retailers' specialist."

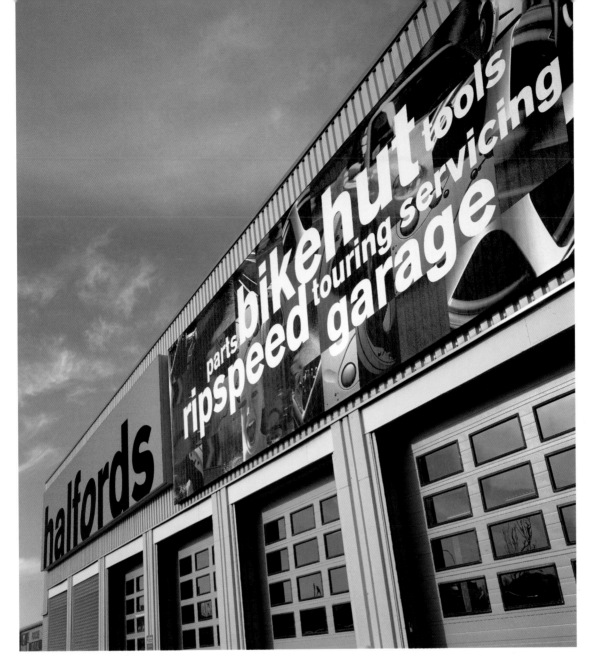

LEFT: Halfords—all things to all people—parts, bike hut, tools, ripspeed, touring, servicing garage—gets a facelift that is bold and unmistakable from a distance. This store is one of 500 locations throughout the United Kingdom. To date, approximately sixty stores have been retrofitted with the new look. The balance will be made over in the coming year.

The new logo isn't fancy; it is simple, straightforward, modern, and bold. The typography sits on the base of a color panel. "As well as allowing the logo to be used horizontally or vertically, it suggests a vehicle on a surface," says Pearce. "The *o* is italicized to imply motion. The brand logotype combined with a typographic expression of Halfords's core offerings, which, together, create a complete brand statement.

HALF⦶RDS

LEFT: The old Halfords identity was tired and in need of rejuvenation. Nothing from the old mark was kept. Everything, from the typeface to the color palette, was replaced in favor of new, modern type and colors.

LEFT: The front of one of Halfords's locations before Lippa Pearce redesigned the retailer's image.

parts store
car audio
bikehut

store
mon-friday 9am to 8pm
saturday 9am to 6pm
sunday 10am to 5pm

The identity campaign rolled out to include everything from the new corporate logo, colors, image, and communication strategy applied to buildings, trucks, literature, clothing, and packaging to a newly developed Web site.

With bold and exciting imagery, the new identity will help to express the recent internal store developments that have taken place at Halfords," says Pearce. "After eight years of working with the brand on both packaging and interior graphics, this project completes the circle to a long-standing relationship between designer and retailers."

What Works

Designers feel that the success of this new identity hinges solely on the redesigned logo. "The mark is bold, single-minded, honest, and credible. It encompasses movement and modernity in a timeless way," says Pearce.

Consumers like what they saw and drove up sales at Halfords by approximately 20 percent following the rollout of the new identity.

"After all the years of working with Halfords on many diverse projects, it's fulfilling to draw the whole thinking process together and create a structure that honestly reflects the new spirit of Halfords," says Pearce.

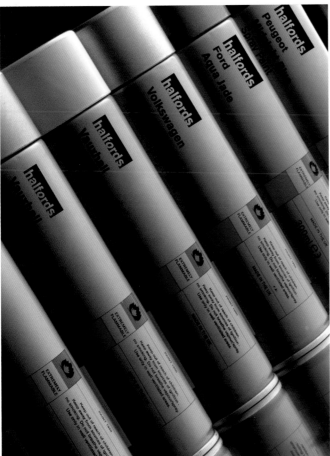

LEFT: Halfords' identity was reproduced in one color on spray cans to give a clean, modern look to its paint packaging. The same look was carried out on the balance of Halfords's private-label products ranging from motor oils, accessories, and cleaning products to several thousand other items.

BELOW: Employee manuals were given an equally clean treatment. Designed in one color, the booklets feature bold cover icons that make each easily recognizable.

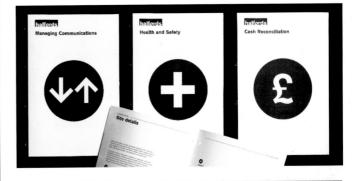

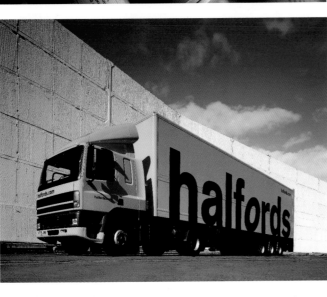

ABOVE: Halfords's trucks are recognizable symbols on busy streets and roadways in the United Kingdom.

RIGHT: The black and orange color palette is complemented by the parts Halfords specializes in, namely, chrome and stainless steel, which, when photographed on the cover of this brochure, give an upscale look to the identity.

Caban:
Minimalist Graphics for the Home

DESIGN FIRM:
Blok Design

ART DIRECTOR:
Vanessa Eckstein

DESIGNERS:
Vanessa Eckstein,
Frances Chen,
Stephanie Yung

PHOTOGRAPHER:
Richard Pierce

CLIENT:
Caban

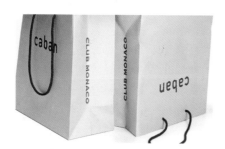

ABOVE: **Caban is a lifestyle store that sells everything for the home from sheets to spices, CDs, and dinnerware.**

The Process

Caban is Club Monaco's new concept for the home—a lifestyle store with everything for upscale living from sheets to spices. Poised to launch the store in Canada, Caban retained Blok Design to do the identity work.

Since Caban was brand new, designers were starting with a blank slate, but there was one dictate from Club Monaco—since it was the mother company—"There had to be a sense of continuity at least in the simplicity and boldness in which both of the brands presented themselves," says Vanessa Eckstein, art director.

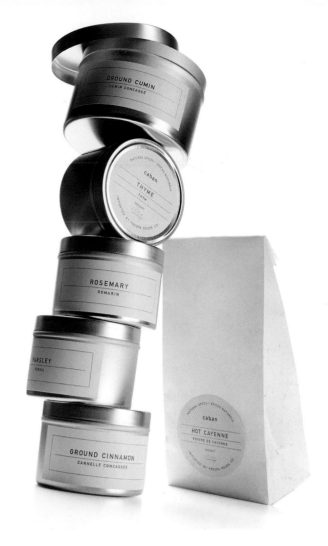

RIGHT: Spices are packaged in aluminum tins with two labels—only one carries the Caban brand name and it is given secondary importance to the name of the spice.

To that end, designers created an identity based on a palette of pale blue and chocolate brown—an atypical, yet trend-setting color combination. The typeface for Caban is bold yet plainly simple—as is everything in the identity. For example, spices are packaged in aluminum tins with clean lines and a cool hue. The brand is fashioned by two labels—one on the side of the tin simply naming its contents. The second label adorns the lid of the tin and is the only place one will find the Caban name, set in lowercase as the primary identity.

"In developing this identity, we needed to provide a visual sense of what Caban stood for, to reflect the interrelation of classic and modern products, and to differentiate it within a highly cluttered marketplace," she adds. "The system needed to be flexible to adapt to any application—be it a label, tag, or sign, and it also had to be specific for every product to feel branded."

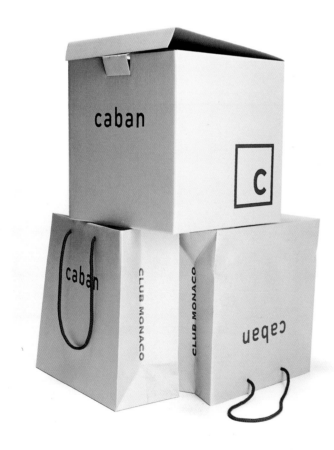

ABOVE: Chocolate brown and pale blue are the only colors used in this identity. Here, boxes and shopping bags feature the palette and bags help consumers note the tie-in to Caban's parent company, Club Monaco, by showing off its name in the bag's gusset.

Boxes and shopping bags are equally austere, yet elegant. The box features an initial C placed off center in a box, while the bags make note of Caban's parent company, Club Monaco, by including its name in the bag's gusset. The initial C logo is unique and upscale enough to stand on its own. More important, consumers see it as a new status symbol and not an obvious sales tool because it is so subtle.

BATH SALTS

RELAX YOUR BODY IN A WARM BATH WITH A TABLE-SPOON OF FRAGRANT SEA SALTS / SEA SALTS, COLOUR AND FRAGRANCE / WEIGHT 300g / MADE IN CANADA

SELS DE BAIN

METTRE DANS L'EAU DU BAIN UNE CUILLER À SOUPE DE SELS DE MER PARFUMÉS POUR PASSER D'AGRÉABLES MOMENTS DE DÉTENTE / SELS DE MER, PARFUM, AGENT DE COLORATION / POIDS 300g / FABRIQUÉ AU CANADA

LEFT: In addition to creating the identity, Blok Design was also given the task of creating collateral material to launch the opening of the stores. This multipart invitation promotes the industry preview of Caban prior to the grand opening of the Toronto, Ontario, location.

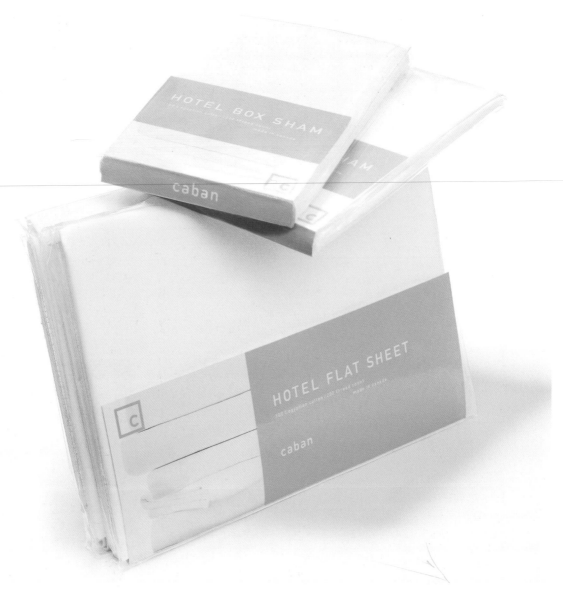

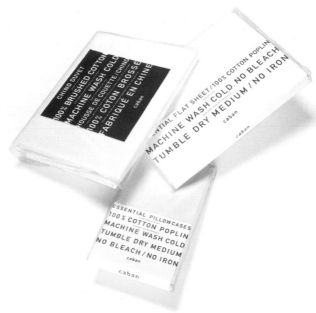

Many of the packaging components—particularly the linen packaging—are designed in one color—either the pale blue or the chocolate brown, which makes a very clean presentation that, when coupled with a lot of products on store shelves, provides a visual punch.

"The identity sends a message of style that is modern and approachable. Bold typography on the linen packaging suggests an authentic presentation of the product—everything is up front and personal," says Eckstein. "There is a simple, no-nonsense yet stylistic approach that sees its way through the entire system."

Designers say that the unique color palette—chocolate and light blue—and bold typographic approach are the most important elements of the identity. "They work as a link between the many elements of the system, from the linen packaging to the spices. Caban feels both unique and consistent," says Eckstein.

RIGHT: In addition to
creating the identity, Blok
Design was also given the
task of creating collateral
material to launch the
opening of the stores.
This multipart invitation
promotes the industry
preview of Caban prior to
the grand opening of the
Toronto, Ontario, location.

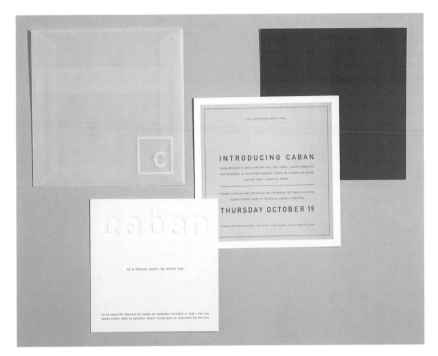

What Works

The design is minimalist at its core. In a crowded,
cluttered marketplace, these graphics stand in stark
contrast; so simple are they that they appear almost
soothing. "The graphics are the basic elements to
build equity, value, and recognition. The strength of
this brand is that it is simple yet memorable," Eckstein
explains. "It responds to a market which is design
driven and that desires quality, style, and value."

To date, designers have been amazed by the response
Caban has received. In the two years since its launch,
Caban has become a nationally recognized brand in
Canada with only five stores in the entire country. It
has also gained international recognition, despite the
fact that, so far, the chain has not stepped out of
Canadian borders.

"Honesty of presentation was a way to appeal to this
market and to be true to Caban's essential offering."

ABOVE AND LEFT: The
identity netted so many
results and kudos for
Blok Design that the firm
summarized much of
its work for Caban in a
miniature selfpromotion.

izzydesign:
izzygraphics for the Nontraditional

DESIGN FIRM:
Square One Design

ART DIRECTOR:
Mike Gorman

DESIGNERS:
Mike Gorman,
Martin Schoenborn,
Grant Carmichael

ILLUSTRATORS:
Shawn Metlon,
Felix Sockwell

PHOTOGRAPHER:
Nate Neering,
Big Event Studio

PRINTERS:
Etheridge Company,
Commercial Printing
Company (identity)

PROGRAMMERS:
Brandon Gohsman,
Grant Carmichael

SHOWROOM
Fabricator: Xibitz

CLIENT:
izzydesign

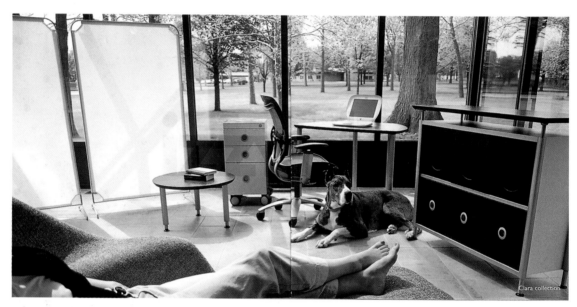

Clara collection

ABOVE: **This brochure
promotes the Hannah,
the Clara Collection,
and the Maxwell lines of
furniture "for people living
the new workstyle."**

The Process

izzydesign is a brand new office-furniture manufacturer located in the heart of the office furniture manufacturing market, Grand Rapids, Michigan. The new upstart was in the midst of a lot of serious competition and knew it; it also knew it needed to be different.

Enter Square One Design, a local firm familiar with the market and fierce competition. Since the company was new, there was no preexisting identity to reckon with—designers, instead, had to focus on the objectives of starting from scratch and then create all materials necessary to launch the new company into the marketplace. The initial goals were simple: distinguish izzydesign as a high-design and people-centric company and help izzydesign differentiate its company within the furniture industry.

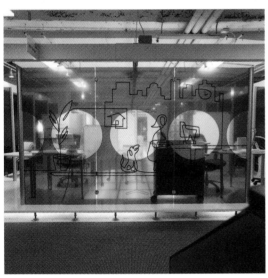

Designers set about achieving the objectives by developing a very simple identity based on color and line art—in the most literal sense. "The use of line art throughout the campaign has provided a simple, fun, yet high design element that is easily recognizable as izzydesign. This line art has helped to relay the message that izzydesign is a furniture company, but not a typical one," says Mike Gorman, art director.

Interestingly, the line art illustrations were placed on translucent panels and used as room dividers in izzydesign's showroom.

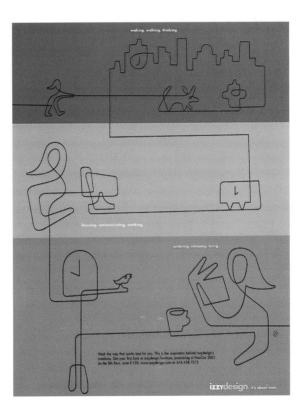

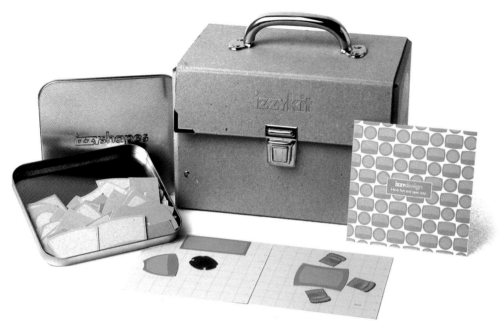

ABOVE: Designers also created izzydesign's sample kit featuring dozens of samples, along with all the parts and floor plan to map out your own office design exteriors.

BELOW: izzydesign's nametag worn by representatives in its trade show booth.

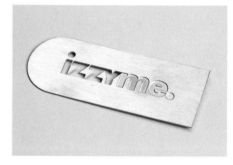

"It's successful because it makes people smile. For example, the unique shape, size, and die-cut combination on the business card instantly puts a smile on your face. It makes people think how this must be a different kind of company and one they would like to work with."

The most important elements of the identity, according to the design team, are its izzyisms. "This play on words, using the company's name, was an instant hit," says Gorman, citing such izzyisms as izzyplay, izzyshapes, izzyme, revealingizzy, which is also the name of a brochure, and izzymmm! "This works because people understand the izzyism concept right away and generally remark on how clever it is. izzyisms make people smile and show that the company is fun and approachable."

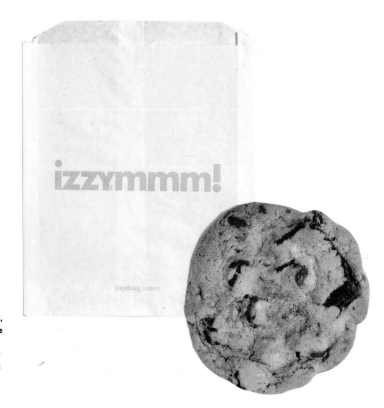

RIGHT: Craving a warm chocolate chip cookie? Well, you're in luck—sort of. One of izzydesign's izzyisms is izzymmm!, printed on a little bag that holds a die-cut cookie. Okay, it's not the real thing, but it is clever.

THIS PAGE: Revealingizzy is a comprehensive brochure on all the collections that features photography showing kids—unusual for an office furniture manufacturer—and is bound with rubber bands, breaking once again with tradition.

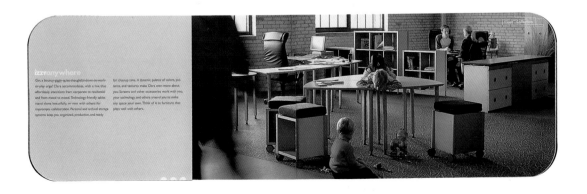

RIGHT: Designers created special invitations for the NeoCon 2001 show in Chicago—one invites attendees to izzydesign's booth, and the other invites special guests to a cocktail party during the event.

"Martini, anyone?"

Office parties aren't for offices, they're for people. izzydesign creates office furniture under the same premise. You're specially invited to witness the unveiling of these designs and toast the accomplishments of our design team. After all, they've been working to make your job more comfortable.

We'll be celebrating at Ghost Bar on June 17 at 6 p.m. We kindly request that you R.S.V.P. by 6/1/01 if you plan to attend, by phoning 616.458.7513 ext. 17.

The Ghost Bar is located in Chicago's Nine Restaurant 440 W. Randolph Street at Canal Street. Sunday, June 17 from 6–9 p.m.

izzydesign

Here's to you.

Free time. Play time. Down time. Work time. More time. izzydesign. Just in time.

Make time to attend the premiere of izzydesign at this year's NeoCon. It will be time well spent, indeed.

NeoCon 2001 will be hosted by the Merchandise Mart in Chicago. Our showroom is located in the Market Suites on the 8th floor, suite E-120. We'll be there on Monday, June 18, through Wednesday, June 20, from 9 a.m. to 5 p.m.

izzydesign

You're in for a real treat.

BELOW: izzydesign's press kit includes several press releases printed on yellow paper and loosely held between two floral printed colored inserts. This is all held in a blue mesh zippered pouch. Slides are held in a matching zippered pouch attached inside the bag that's the size of a change purse.

BELOW: Tags identifying furniture are made of a heavy stock and hang from the furniture by colorful rubber bands. The furniture in this line has familiar first names, such as the Zachary and the Maxwell. The reverse gives information on the specifics of the furniture.

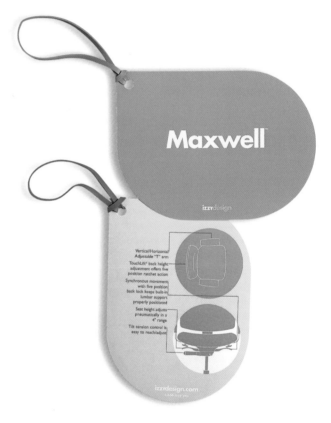

Maxwell

izzydesign

Vertical/Horizontal Adjustable "T" arm

TouchLift® back height adjustment offers five position ratchet action

Synchronous movement with five position back lock keeps built-in lumbar supports properly positioned

Seat height adjusts pneumatically in a 4" range

Tilt tension control is easy to reach/adjust

izzydesign.com

This all sounds pretty unconventional for a traditionally conservative market, but izzydesigns doesn't stop there. Brochures are bound with rubber bands and are made of unusual materials; they also feature creative diecuts and use varnishes in different ways. The content is equally offbeat, and most notably, children are featured in many of the photographs, which is part of izzydesign's differentiated selling points—furniture "for people living the new workstyle."

The graphics provided a broad-based market appeal "by striking a balance of line illustration, izzyisms, spontaneous photography—including the use of children in the photos—bold color, and various production techniques," says Gorman. "People have taken notice of these design solutions and that has helped to set izzydesign apart."

izzy go

izzydesign.com
Summer 2002

Hannah, Zach, Gracie
Seating that could become
your new best friend

Campers
(at work)

People rule
from Airstream
to Maxwell

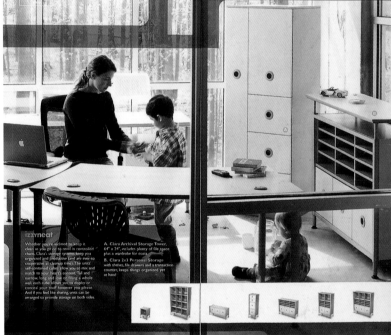

izzyneat

Whether you're inclined to keep it
clean as you go or to revel in controlled
chaos, Clara's storage systems keep you
organized and productive (and are ever-so
cooperative at cleanup time). The units'
self-contained cubes allow you to mix and
match to your heart's content. Tall and
narrow, long and low or filling a whole
wall, each cube allows you to display or
conceal your stuff however you please.
And if you feel like sharing, units can be
arranged to provide storage on both sides.

A. Clara Archival Storage Tower,
64" x 24", includes plenty of file space
plus a wardrobe for coats.
B. Clara 2x3 Personal Storage
with shelves, file drawers and a transaction
counter, keeps things organized yet
at hand.

What Works

"The simple clean visuals; use of line art throughout the campaign; consistent, fun
copy; photography style make it work," says Gorman.

The printed materials have elicited an enthusiastic response from most audiences.
Moreover, the use of unusual materials, diecuts, and bindery techniques has allowed
izzydesign to stand out among the other more conservative furniture companies.

The company was officially launched in 2001 at NeoCon Chicago, the furniture
industry's largest annual trade show. "The traffic in their showroom/booth during
that show was double what was expected," reports Gorman. "izzydesign caused
quite a stir during and after that trade show, gaining much press coverage and
winning an Editor's Choice award for their Clara collections line of products."

LEVI'S 501 JEANS:
The Biggest Little Number in Clothing

DESIGN FIRM:
Mike Salisbury
Communications, L.L.C.

CLIENT:
Levi Strauss & Co.

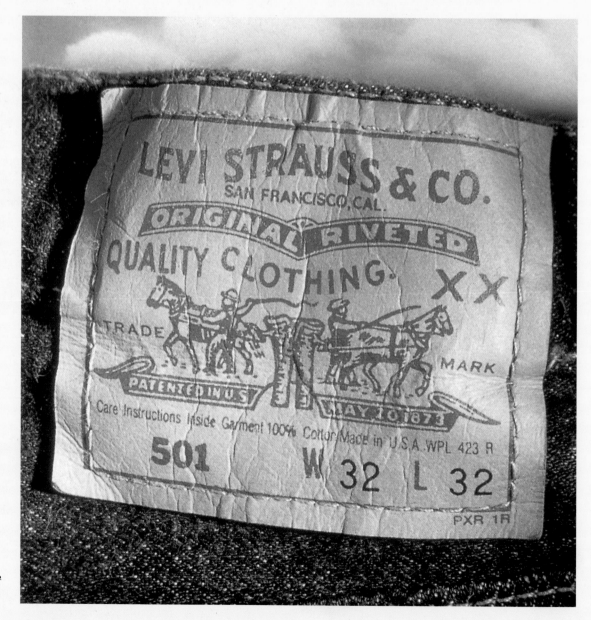

RIGHT: The original source
of the 501 brand—the
product stock number.

The Process

How did Levi's 501 jeans get their name? One might just as well ask, "Why is the sky blue?" because, like the sky, Levi's 501 jeans are something taken for granted. To that question the average jeans-buying consumer might respond, "What? Weren't they always called Levi's 501 jeans?" The answer is 'no.' In fact, Levi's 501 have become such an all-American icon, it seems as if that name has been around for ages, so it is surprising to note that it is a relatively new development.

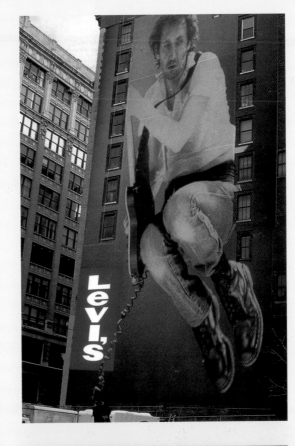

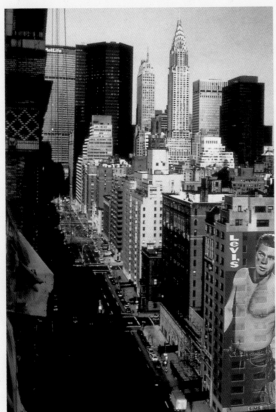

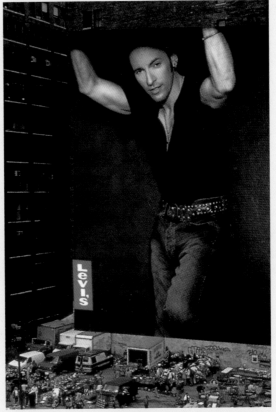

A Look Back

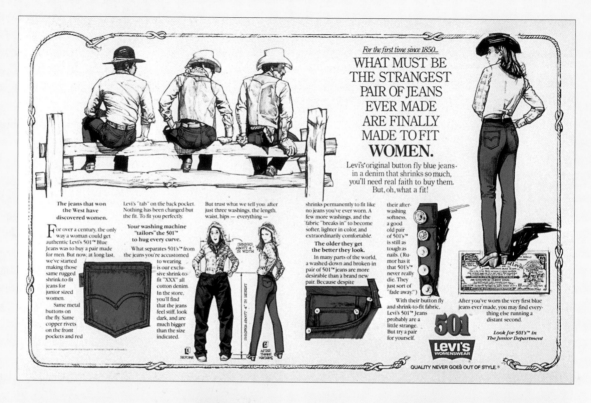

For the first time since 1850...

WHAT MUST BE THE STRANGEST PAIR OF JEANS EVER MADE ARE FINALLY MADE TO FIT WOMEN.

Levi's original button fly blue jeans- in a denim that shrinks so much, you'll need real faith to buy them. But, oh, what a fit!

The name actually arose from a suggestion Mike Salisbury of Salisbury Communications L.L.C. made while working on the branding for a Levi's jean product for women. As Salisbury tells the story, for years, women in California had been remaking Levi's jeans for men by soaking them in bathtubs filled with warm water to shrink them to fit their bodies. While this habit wasn't well known in the rest of the country, Levi Strauss & Company realized what they were doing and saw an opportunity. The company developed Levi's Shrink-to-Fit Button Fly Jeans For Women. Salisbury was hired to create an advertising campaign to introduce this new, yet old, product.

"Research said that what was taken for granted in California— that you had to buy Levi's oversized and shrink them to fit— was largely unknown outside the West. My concept to present this new version of an American classic was to create a new symbol of communication to simply explain that what fits men now fits women," says Salisbury.

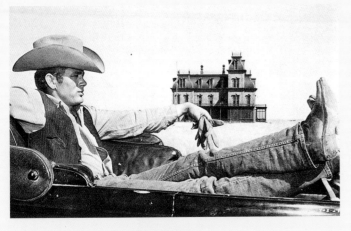

Salisbury draws a lot of his inspiration from pop culture, particularly Hollywood films, so that's where he turned for his idea. "I put a female in a well-known male situation: a situation in which jeans were an organic part of that situation," he explains. "The ultimate symbol to me was James Dean putting his feet up on the back of that car seat, leaning back in the rear seat, slumped down with his hat pulled over his eyes in the film *Giant*. My James Dean was a lady." Salisbury combined these two "easily understood and known symbols" and by doing so, created a visual metaphor for Levi's new product.

The visual metaphor said what no words would explain in billboard advertising and venues where long explanatory copy was prohibitive. However, clients like to talk about their product, so long copy print ads with well-defined illustrations outlining the whole shrink system were created to explain how these Levi's fit women—especially their behinds.

THIS PAGE: Salisbury's idea to sell the concept of Levi's 501 Shrink-to-Fit jeans for women was to create a visual metaphor starting with the image of a famous male icon in jeans—James Dean, as shown in the film, *Giant*, and replacing him with a woman.

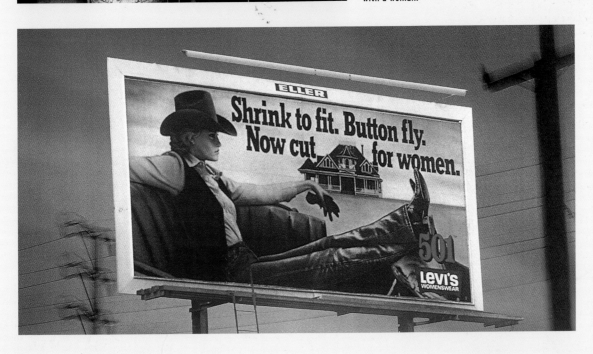

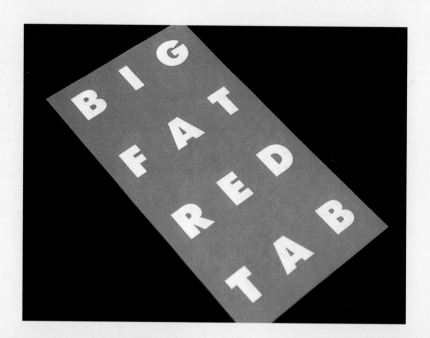

BIG FAT RED TAB

BELOW: This bus poster for a Levi's product is graffiti proof.

LEFT: Salisbury's concept for a modern-look baggy jean refers to the Levi's brand equity and identifiers as the basis for the product name.

"Originally the tagline to accompany the ad was 'Levi's Shrink-to-Fit-Button-Fly Jeans-Now-Cut-For-Women.' That's kind of a lot of words for the teeny little space left over on a billboard, print ad, or TV screen," says Salisbury. "Who needs words? The client needs words…that's who. It's their product. But we needed a catch— no one would remember to say all of that when they went into ask for some jeans. We needed a brand.

"Just call the damn things what we call all of them—501s and trademark it!" Salisbury remembers telling the client, referring to Levi's internal stocking number. "That's how Levi's 501 came to be the most well-known brand of clothing in history. It was a combination of everything—simplifying a wordy tagline to a number and reinforcing it with a cohesive, strategic ad campaign. Thus the most famous clothing brand in the world was given to the public to use 100 years after its invention: Levi's 501 jeans—the biggest little number in clothing."

ABOVE: This magazine was given away free at retail to resell the Levi's core brand values to the jeans-buying public.

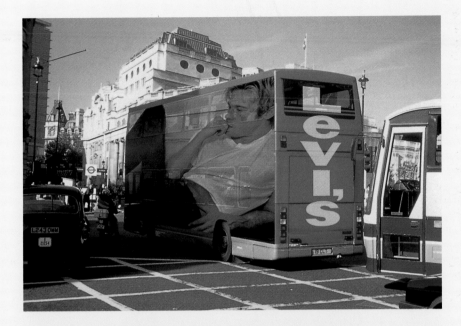

LEFT: Salisbury Communications, L.L.C. created this campaign for the ad firm Foote Cone Belding when Geoff Thompson was president. "My concept was to bring back to Levi's their brand identity—the world's pants. No fads. No age date."

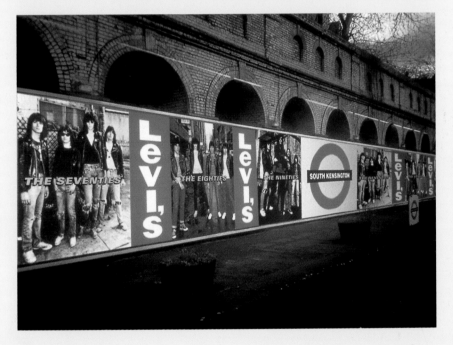

ABOVE: The goal of this campaign was to show the timelessness of Levi's jeans, so Salisbury crafted this ad to picture the group, the Ramones, at every stage of their career while wearing the same jeans.

What Works

Today, it's that three-digit number—5-0-1— and the little red tag that consumers readily identify with Levi Strauss & Company. They don't need to know more. That number and the sight of a red tag on the jeans pocket readily identifies them as Levi's products. In fact, if Levi's wanted to, they could probably do without their name on the red tag, the product is that recognized.

So, how did a solution so simple, become an American product icon? Happenstance? Coincidence? A meeting of the minds? Perhaps all of these things. But Salisbury has his own take on how promoting a line of women's jeans revolutionized product branding at the retail level.

"Usually it's the obvious that escapes people, like the world's most famous jeans not even having a brand name, or the fact that Joe Camel was already on the packet."

Corporate

The category of corporate marketing is often a misnomer. Sometimes it is relegated to being a catch all category that implies staid, blue-suited, conservative companies doing business in the concrete jungle. When we say corporate, we're talking business-to-business marketing. It's like marketing to your peers; peers who know the ins and outs of business just as well as you do.

Peers know all the tactics; they've heard all the sales pitches; they know all the ploys. So how does a business market to its own? Does it sell with straight talk? Does it try to dazzle and impress? Is there one way to present your identity to such a diverse marketplace?

The stories told on the following pages show that the answer may be in a mix of professionalism, innovation, creativity, and practicality. The latter is possibly the most important. In today's hectic up-and-down economy, businesses are less impressed by gimmicks and the wining and dining of old. More important is the bottom line. What's in this for me? What are the benefits to my company? How will it make my job easier?

The following pages look at the success stories of companies marketing to journalists, architects, bankers, interior designers, and businesses of all kinds. In each case, they found the right mix of visuals and copy to send a message that sells.

EAI: Graphics That
Make You Think

DESIGN FIRM:
EAI

CREATIVE DIRECTORS:
Matt Rollins, Phil Hamlett

DESIGNERS:
Matt Rollins, Todd Simmons

CLIENT:
EAI

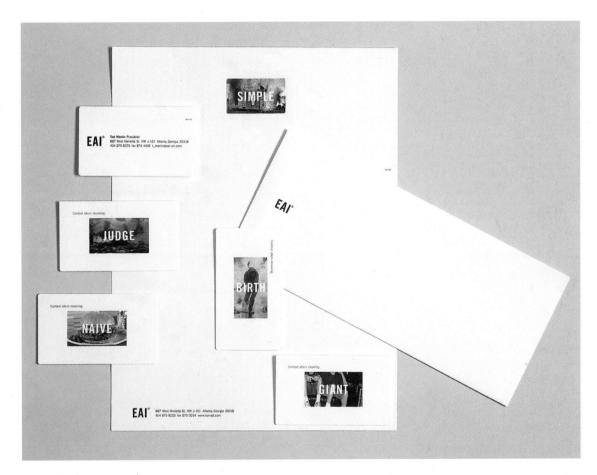

The Process

EAI was born Executive Arts, Inc., but it wasn't long before its legal name seemed to get lost in the marketplace. "We first noticed the truncation when clients started referring to us as Exec Arts," remembers Tod Martin, president, EAI. "Over time, clients and the marketplace have shortened that to EAI."

Once the company made the decision to start using the initials as its primary identity, the firm went into a transitional phase, producing an award-winning identity system that incorporated both the full name and the acronym. "The shift to the new system was a conscious decision to clarify the branding for the firm using the moniker that the marketplace tends to prefer," says Martin.

Designers set out to reinforce five key brand characteristics of EAI with the new identity:

▶ **Mystique**
"EAI is small, independent, hard to categorize, and has consistently exhibited influence disproportionate to its size," says Martin.

▶ **Team**
EAI does not get its reputation from a marquee designer, but is multi-individual, drawing on the interrelated knowledge and skills of many team members.

▶ **Passion**
EAI's work style is marked by intensity, energy, and the conviction to champion the better idea based on well-grounded beliefs.

▶ **Stimulating**
"Our environment encourages people to be mentally agile, culturally aware, and socially conscious," says Martin.

▶ **Changing**
"We foster an open, growing, learning environment that is vibrant rather than static," Martin adds.

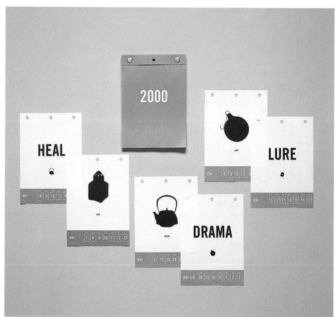

In order to encompass all these characteristics, EAI designers strove to create an identity system that engaged people and encouraged them to reflect on how communications work. "Likewise, we wanted to create a system that could continuously evolve and yet still build brand equity," Martin says.

The identity system is built around the idea that context alters meaning—in fact, this concept is printed on the identity and explored in a variety of ways but, most prominently through the juxtaposition of familiar words and pictures in unexpected pairs. "Out of the unexpected, a new context is created and, thus, a new meaning," Martin explains. "These juxtapositions never—intentionally—tell a complete story. Rather, they simply challenge in a smart, playful manner. They create contextual tension. They are at once utterly simple and exquisitely produced, straightforward, and unexplainable, visually humorous and intellectually perplexing, original and found, candid and complex, black and white and gray."

LEFT: EAI's identity is deceptively simple. Outwardly, the initials are bold, yet unassuming, whether they appear as black type on white or blind embossed on white or blue.

The new logo is deceptively simple; the firm's initials stand unadorned in stark contrast to its background whether it be black on white, black on blue, embossed white on white, or embossed blue on blue. "The stark appearance and poetic placement of the logotype, however, give it presence and weight," says Martin. Perhaps the best descriptor of the identity is that it is pure and unaffected. In fact, pure is a word that appears frequently throughout the identity—against the silhouetted image of a double Popsicle. It accents a T-shirt and is one of many word icons that decorate EAI's gift wrap.

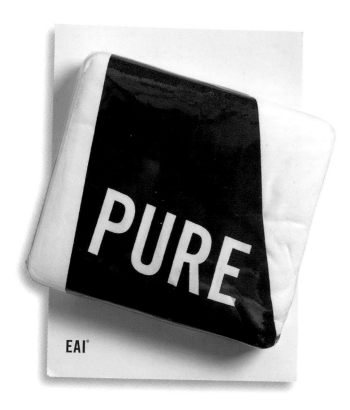

LEFT: EAI uses black-and-white picture icons matched with words on company gift wrap to express the concept that content alters meaning. "Everyone here understands the brand. Because they see themselves in it, they never fail to express or deliver the brand as we envisioned it," says Martin. "The identity is a living part of the culture, which makes it both more powerful than a typical identity system capable of growing and changing with us."

FAR LEFT: "The identity system itself has an unusual level of restraint, which lends a clean, classic feel," says Martin, pointing to EAI's notepad and T-shirt.

RIGHT AND FAR RIGHT:
The identity revolves around a cultural identity manual called EAI 4.0, referring to Version 4.0—the fourth incarnation of the firm.

BELOW: "I Think I Am A Verb" is an EAI publication that provides an overview of the firm's work for clients such as IBM, The Coca-Cola Company, and Hewlett-Packard, among others. "EAI is small, independent, hard to categorize, and has consistently exhibited influence disproportionate to its size," says Martin.

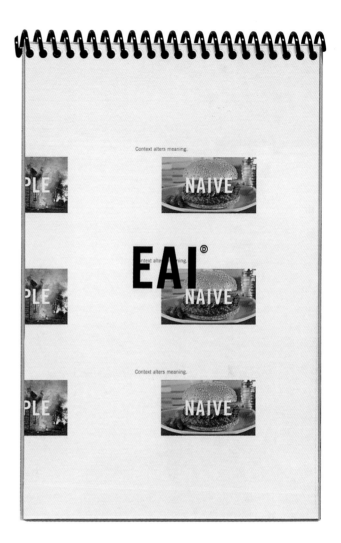

The identity also revolves around a cultural identity manual called *EAI 4.0*. "The process of developing 4.0 was a conscious decision to acknowledge that the firm has evolved through several different versions of itself. Originally, the firm—in its version 1.0, if you will—was a general graphic design shop," says Martin. "Version 2.0 began when EAI began working with RJR Nabisco and gained a foothold in multinational corporate communications. When Lou Gerstner moved from RJR Nabisco to IBM, EAI got the opportunity to be involved at the nucleus of a big corporate turnaround, which marked the beginning of version 3.0. Unlike the shifts to 2.0 and 3.0, the shift to version 4.0 was not an event-triggered change. We elected to broaden the focus of the firm, using the diverse skills we had honed working in large corporations to also work with start-ups, small- and mid-cap companies, as well as in socially and environmentally conscious organizations."

According to Martin, EAI's new identity is successful because it is an accurate and meaningful reflection of the people, environment, and products it is meant to represent. "We are the origin of our identity—we are familiar elements combined in unexpected ways," he explains.

"On a different level—a developmental level—what makes the new identity successful is that it was not the product of a single person, but was the product of a collaborative process. Everyone at EAI (well, all twenty-eight people, but probably not the six dogs) can see him- or herself in the identity. That isn't to say that it was an inefficient, designed-by-committee process, but that it was a collaborative process that drew on the ideas, thoughts, and contributions of many people."

Designers created this identity to affect the mind of the person looking at it. "Rather than just searing a mark into people's minds and asking them to associate their perceptions, experiences, and beliefs about EAI with that mark, our identity system engages people's minds, making the identity itself something that shapes perception, experience, and, potentially, belief," says Martin.

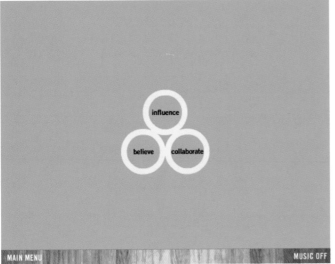

ABOVE: EAI's Web site carries through the theme of matching graphics with words to provoke the thought process. "The graphics themselves—particularly the word/picture images and the icons—are more provocative and bold. The combination creates a certain level of tension, but from a different perspective gives the identity the ability to embrace all of our market, which spans from corporate to creative types. The graphic elements are central to the success of the identity, since the graphics help explore how context alters meaning," says Martin.

What Works

"Ultimately, what works about the new identity system is that it succeeds in engaging people," says Martin. "From our business cards, which each have one of ten word/picture images on them, to temporary tattoos, which feature some of the silhouette icons, the identity system opens a dialogue. It facilitates communication."

The system has garnered numerous design awards, including recognition in Communication Arts' *Design Annual*, the American Center for Design 100 Show, and AIGA, as well as honors from the Type Directors Club. More important, since the launch of the new identity and support materials, EAI has won six new clients and received a three fold increase in media coverage. It has also spawned several knock-off identities by competitors, according to the EAI team.

Melbourne Press Club:
Delivering the Hard News

DESIGN FIRM:
Smart Works

ART DIRECTORS:
Paul Smith, Andrea
Rutherford

DESIGNERS:
Paul Smith, William
Jamieson (Web site),
Ben Loke (multimedia)

ILLUSTRATOR:
Paul Smith

CLIENT:
Melbourne Press Club

MELBOURNE
PRESS CLUB

The Process

When the Melbourne Press Club approached Smart Works for a new identity, its logo was flat and uninspiring, featuring a red fountain pen nib writing the organization's name. "It was very one-dimensional and out of date. They also had two different logos," says Paul Smith, co-art director on the project, pointing to a second mark that features a capital letter *M* alongside a lowercase *pc* in a red circle with the words Melbourne Press Club. "The red on both was too harsh for a press club and looked like blood."

Designers thought that the fountain pen nib was a great concept—one worth keeping, but they wanted to make it more stylish and give it added dimension. Most important, they wanted the new logo to reflect the essence of journalism, the club's heritage, and professional function. They reworked the fountain pen with a free-flowing illustration and added an ink mark that suggests the shape of a quotation mark to symbolize creativity and movement. The result is an elegant, simple, clean, dynamic, and recognizable mark that, combined with the stroke represents journalism.

"The modern colors and stylized graphics stand out dramatically even from a distance," says Smith. "The form is simple and durable, yet elegant in design. The simplicity and elegance helps the client compete and enforce the brand—giving the brand longevity in the workplace."

ABOVE: Designers wanted to keep the fountain pen nib, but they reworked it into a freeflowing illustration and added an ink mark that suggests the shape of a quotation mark to symbolize creativity and movement. The result is an elegant, simple, clean, dynamic, and recognizable mark that, combined with the stroke, represents journalism.

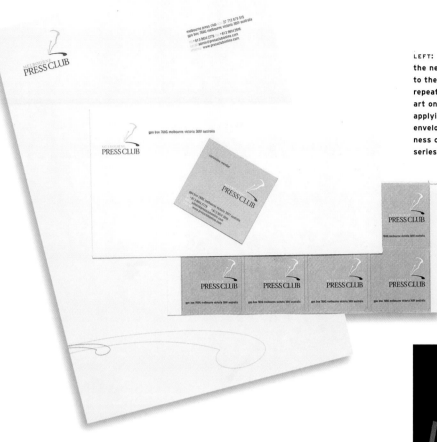

LEFT: Designers adapted
the new pen-and-stroke logo
to the letterhead package,
repeating the stroke as line
art on the letterhead and
applying the identity to
envelopes and square busi-
ness cards, as well as to a
series of stickers.

BELOW: The major sponsor
for the journalism confer-
ence was Telstra (Australia's
biggest telecommunications
company.) In honor, the
designers transformed the
ink mark of the logo into
a telephone with the title,
date, and venue projecting
out of the handset like
a voice.

Designers adapted the logo to the letterhead package, repeating the stroke as line art on the letterhead and applying the identity to envelopes and square business cards, as well as to a series of stickers.

Likewise, the identity is center stage on the Press Club's home page (p.38-39), then moves to the upper and left corner of succeeding Web pages where the mark is featured in the center of an enlarged version of the stroke.

BELOW: When the Melbourne
Press Club approached
Smart Works for a new
identity, it was using two
logos. One featured a red
fountain pen nib writing the
organization's name. The
second mark featured a
capital letter *M* alongside a
lowercase *pc* in a red circle
with the words, Melbourne
Press Club. Both were very
one dimensional, dated,
and uninspiring, according
to designers.

WELCOME to the Melbourne Press Club

Our web site is designed to help achieve our mission of celebrating the best journalism in Victoria and advancing professional standards while providing forums for debate and support for members.

created by

THIS PAGE: The Melbourne Press Club's new Web site features a black-on-black motif where the logo is reproduced in white and gray on the dark background. In stark contrast to much of the Web content, the Quill Awards page appears as gray on gray.

With the heart of the identity complete, designers tackled the next project—
creating a subidentity for the club's prestigious Quill Awards. Here, designers
created new artwork that uniquely resembles the stroke in the original
logo. "The ink stroke is open to interpretation. It can even form the shape
of features used in the 2000 Quill Awards—forming a duster and lyrebird,"
says Smith.

The Quill Awards has an introductory page in the primary hierarchy of the
Press Club's Web site, which provides entrée to an animated sequence
devoted to the awards. It begins with a quill that turns into the award. In
the end, the stroke from the original logo is evident in the lower right corner
of the computer screen, as is a portion of the stroke as line art in the upper
left corner.

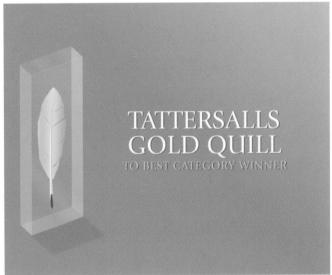

THIS PAGE: **The Quill Awards has an introductory page in the primary hierarchy of the press club's Web site, which provides entrée to an animated sequence devoted to the awards. It begins with a quill that turns into the award. In the end, the stroke from the original logo is evident in the lower-right corner of the computer screen as is a portion of the stroke as line art in the upper-left corner.**

What Works

The press club has had positive feedback both locally and overseas and is now recognized by most Australian journalists as leading the way in its endeavors. Membership numbers and sponsors have increased dramatically.

ComCab:
Driving Home a Message

DESIGN FIRM:
Trickett & Webb Limited

ART DIRECTORS:
Brian Webb, Colin Sands,
Lynn Trickett

DESIGNERS:
Colin Sands, Alistair Brown

PHOTOGRAPHER:
Glynn Williams

CLIENT:
Computer Cab

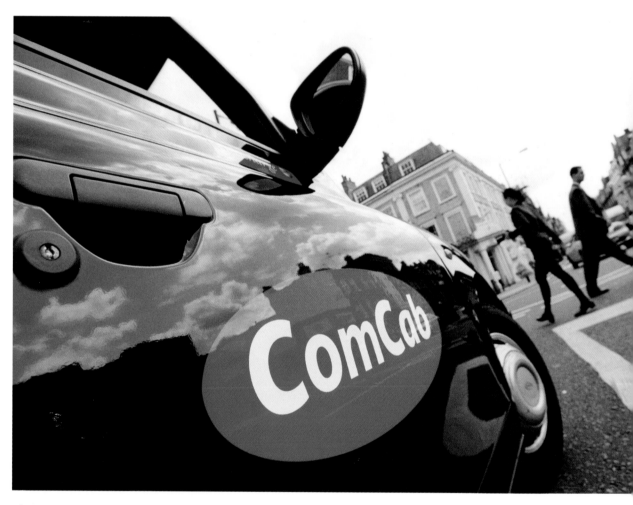

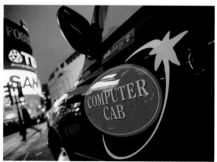

LEFT: In 1995, Computer Cab used a logo designed by Trickett & Webb that promoted its new dispatch system, called Mobistar, but by 2000, this logo was ready for another makeover.

ABOVE: "Black cabs on the street are taken for granted, like red London buses. The red ellipse on the side of the majority of London taxis identifies the company and the services it offers," explains Brian Webb of the 2000 logo redesign.

LEFT: This new logo was introduced in 2000 to coincide with a new branding that shortened the company's name to ComCab, as it has become known to customers.

The Process

Computer Cab got its name because, when it started up in 1981, it used a computer system for job tracking and billing at a time when taxi companies operated as a man and his cab. Since the company operates the largest cab fleet in London, the name on the side of the cab needed to be strong so that pedestrians looking to hail a cab speeding through city traffic could immediately find Computer Cab.

Trickett & Webb was hired to give its identity a makeover. Beginning in 1987, they revised its original logo, which used an old-fashioned telephone as its icon, and remade it again in 1995 when the company introduced a new taxi location and dispatch system, called Mobistar. In 2000, the time was right for yet another identity update.

"The objectives of the rebranding were to build in the strength of the name and to reinforce the professionalism of the company in all its communications," says Brian Webb. "The company now operates in a worldwide network with its credit card brand—CabCharge, and its GPS satellite control system, Mobistar—both identities designed by Trickett & Webb."

This time, when Trickett & Webb revisited the logo, they recommended shortening the company's name to ComCab for two reasons. Foremost, computers, which were a novelty when the company started in the early 1980s, are now considered commonplace. Besides, designers reasoned, Com could just as easily stand for community. Secondly, ComCab was the familiar nickname that consumers used to refer to the company. Why not use a name that was coined by the target market?

With that, designers modified the red ellipse of the old logo and strengthened the typographic treatment of ComCab. "Black cabs on the street are taken for granted, like red London buses. The red ellipse on the side of the majority of London taxis identifies the company and the services it offers," explains Webb.

LEFT: The shortened name, ComCab, appears in logo form on the company's stationery system along with its legal name, Computer Cab.

RIGHT: Computer Cab logo 1981–1987

FAR RIGHT: The 1995 logo update introduced Computer Cab's new dispatch system, Mobistar

"Most cabs are used on company accounts. With its Mobistar
GPS system, ComCab gets a cab to your door quicker than the
competition. The billing system makes charging to jobs simpler.
The CabCharge credit card system is billed back to your
account without the need to carry money. Clients can use
CabCharge almost anywhere in the world and have it billed
back to the their accounts; you can phone for a cab to take you
to the airport in London and have a cab waiting to collect you
at the airport in New York, Sydney, or Singapore."

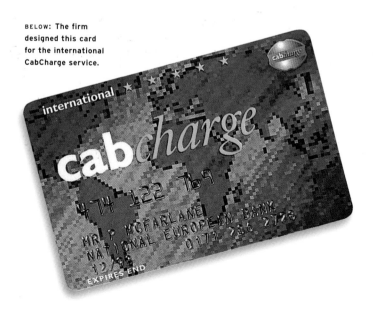

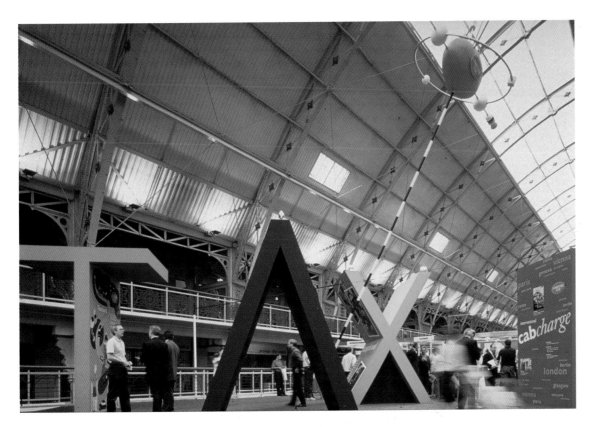

The new ComCab logo is the most important element in the rebranding, according to Webb, but that doesn't diminish the importance of the company's annual reports, interiors, and control room—they get a lot of visitors—which all play an important role in the identity, and were designed by Trickett & Webb as part of a massive rollout announcing the name change. "[Each piece played] an essential part in signaling the success of the company, right down to the packaged Christmas presents given to clients, company staff, and drivers," says Webb.

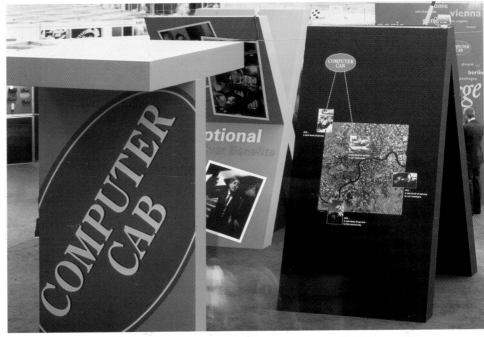

ABOVE: This exhibition stand promotes the Computer Cab services and is made of giant letters that spell TAXI. Each letter describes a customer benefit. The Mobistar "satellite" flies high above the exhibition, dotting the I in TAXI and marketing the exhibit location.

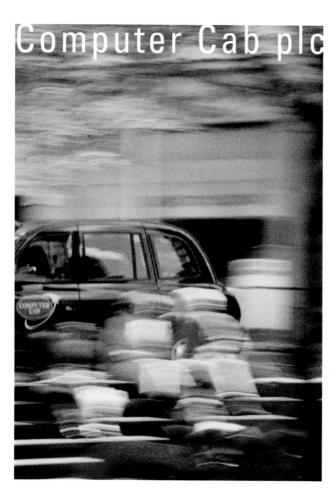

Computer Cab plc

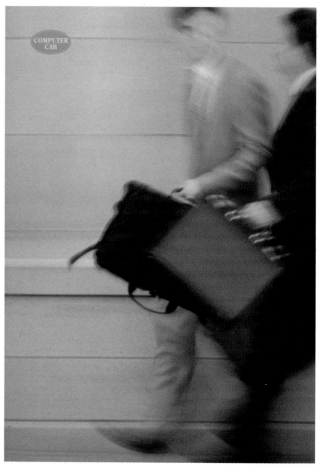

THIS PAGE: **Designers imparted the illusion of speed into collateral material for Computer Cab, including this brochure promoting the company's services.**

"By creating a strong visual identity on the street, more drivers want to work for ComCab. The company can select more reliable staff, thus offering a better service twenty-four hours a day, 365 days a year," he adds.

"Taxi companies have traditionally had a reputation for unreliability and rudeness. By presenting the company as professionals, the service has improved, billing systems, and communications are efficient, and only the best people now work for the company—an upward spiral."

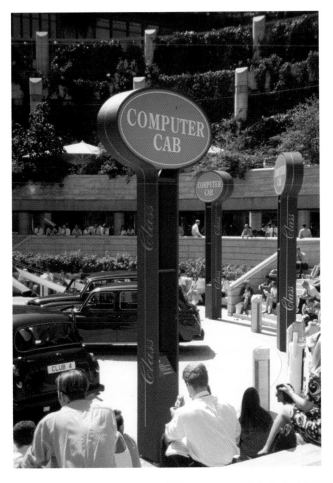

LEFT: The red ellipse used for the company's logo had built-in recognition throughout London, where it could be in this outdoor exhibition to promote the new executive cab service.

What Works

"Basically, every taxi company is the same—a cab and a driver," says Webb. "What makes the difference is the level of service, the Computer Cab identity, and communications emphasize quality of service. ComCab clients are city banks and brokers, law firms, and advertising agencies—everybody who needs to move people efficiently. Many clients now have remote booking terminals in their own premises. ComCab is seen as the leading taxi company in London."

RIGHT: Each piece created for the promotional program played "an essential part in signaling the success of the company, right down to the packaged Christmas presents given to clients, company staff, and drivers," says Webb.

KNHS:
Unifying Seventeen Groups as One

DESIGN FIRM:
Ping Pong Design

**ART DIRECTOR/
DESIGNER:**
Ping Pong Design

PHOTOGRAPHER:
A. Arnd

CLIENT:
KNHS Royal Dutch
Equestrian Association

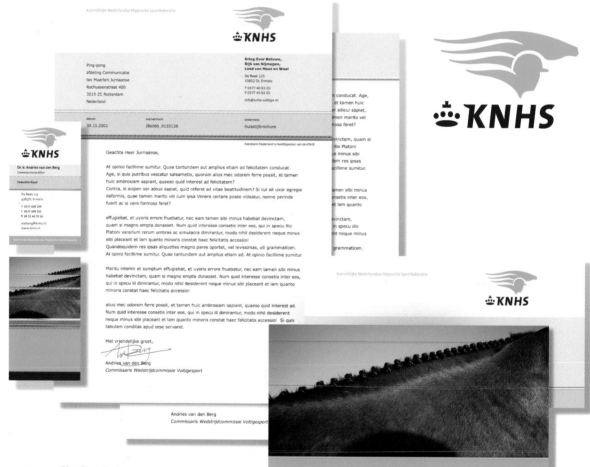

**ABOVE RIGHT: Ping Pong Design
created the logo for KNHS, the
Royal Dutch Equestrian Association
to represent the unification of
seventeen separate organizations.
The design is subject to interpreta-
tion, according to designers. "Some
see a horse and rider," says Mirjam
Citroen, of Ping Pong Design.
"Others see only a dynamic,
forward-moving form. The visual
interpretation is, therefore, highly
personal; and the more personal
something is, the more memorable
it becomes. In such a situation,
ready acceptance is a given."**

The Process

Until recently, seventeen independent organizations represented equestrian sports
in the Netherlands, where equestrian events and activities are big business on a
local, national, and international level. Each organization operated with its own
mission, statue, agenda, and public, until each realized it could better serve the
sport and its constituencies if they merged into a single association mandated to
represent Dutch equestrians across the board: top-class competition, and recrea-
tional riders, and the people and facilities that support equestrian activities.

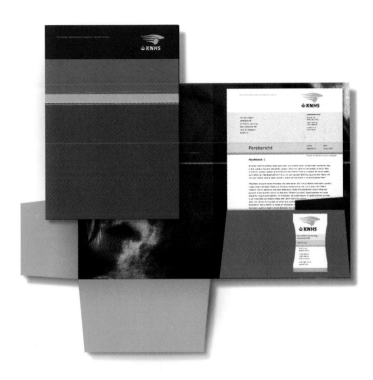

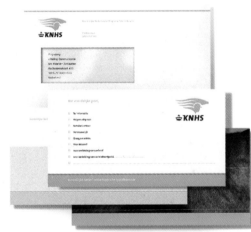

To introduce the newly merged organization to its audiences, KNHS, The Royal Dutch Equestrian Association, as it was named, retained the firm of Nijkamp and Nijboer to develop an introductory strategy, which was formulated by Gert Koostra, and Ping Pong Design to execute the identity and collateral. The entire creative process was allocated a mere six weeks—thirty working days to conceptualize and produce a trademark, letterhead package, clothing, and the overall design program. "This tight deadline intensified the collaborative process," remembers Mirjam Citroen, of Ping Pong Design. "Strategist, designer, and client worked closely and intensively to forge an identity that united the previously independent equestrian organizations visually and emotionally."

Work began immediately on the logo. Designers took stock of the various mindsets represented by the different associations who were banding together to form a single unit and translated these into a form that amply—and jointly—represents their individual needs and concerns.

"Some see a horse and rider," says Citroen. "Others see only a dynamic, forward-moving form. The visual interpretation is, therefore, highly personal; and the more personal something is, the more memorable it becomes. In such a situation, ready acceptance is a given."

THIS PAGE: The KNHS logo was designed to be flexible enough to work on any number of applications, whether from a stand-alone mark on a coffee cup or reduced in size for use as an insignia on clothing or engraved on a trophy. Designers adapted the logo to a variety of elements in a comprehensive stationery package.

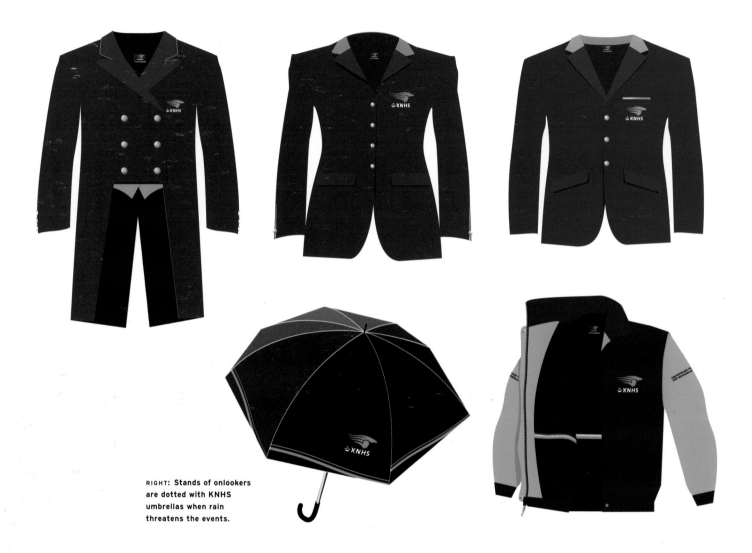

RIGHT: Stands of onlookers are dotted with KNHS umbrellas when rain threatens the events.

The graphics work within a variety of color combinations, giving it plenty of flexibility so that it can be applied to any number of applications, from the letterhead package and clothing items, such as blazers, to promotional items including blankets, coffee cups, and horse trailers. It also works digitally on a Web site and is equally as effective when reduced in size for use as an insignia or engraved on a trophy.

Designers aren't saying how easy it was to get approval on the design from a unified group of seventeen, but now that KNHS speaks with a single voice, its opinion is overwhelmingly positive. "The graphics present a unified presence among the seventeen previously independent equestrian associations without limiting or infringing on the necessary autonomy still exercised by the different groups," says Citroen.

ABOVE: The logo was designed to work on clothing as a pocket insignia as well as on something as seemingly insignificant as the clothing tag inside the garment, which gives the garment a special air of exclusivity.

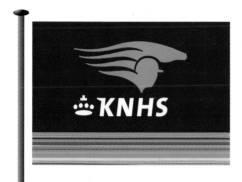

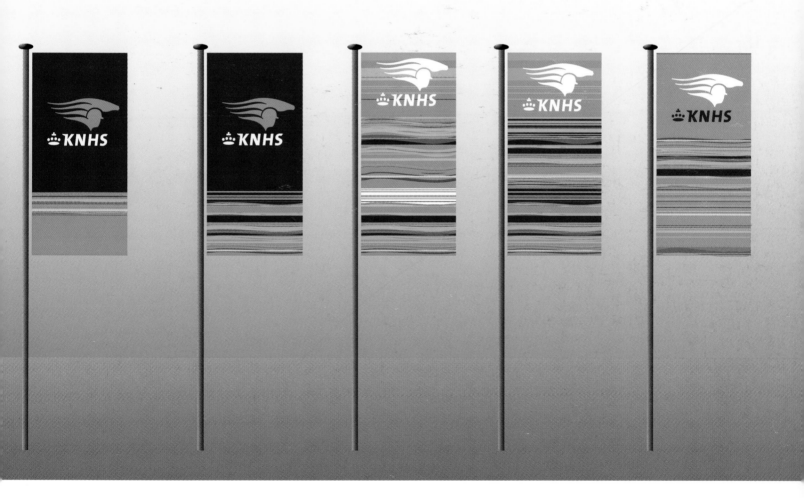

Koninklijke Nederlandse Hippische Sportfederatie

KNHS

>>>kracht

////Topsport in de nationale arena////

ABOVE: The design of the
introductory brochure fea-
tures a horizontal graphic
pattern of photographic
images that appear to
move across the cover
like a filmstrip, giving the
feeling of speed.

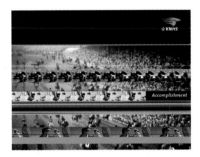

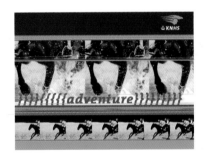

THIS PAGE: At the client's request, Ping Pong Design conducted a style study on the flexibility and "bandwidth" of the brand to distinguish different target groups from men's and women's top-class and competition riders to recreational riders as these different target groups have their own communication vehicles—brochures, magazines, and events. To designate materials for each group, designers added a subcolor palette and integrated different typography into the design of collateral pieces.

What Works

"The fact that it incorporates the needs, vision, and ambitions of seventeen previously independent equestrian associations helped make it successful, but also the possibility and range of the logo form itself," says Citroen on why the logo works so well. "It is serious enough to depict the focus and discipline inherent in world-class equestrian sport, and it is congenial enough to depict the devotion and affection implicit in young riders and hobbyists.

"The result was that within a remarkably short period of time, we developed a unified style and brand identity that met the needs and fulfilled the expectations of all seventeen associations—no small feat! Our activities proved to be the binding factor that has since allowed the organization to move ahead as a singular organization representing Dutch equestrians at home and abroad."

Acuiti Legal:
Graphics That Break the Law

DESIGN FIRM:
CPd

ART DIRECTOR:
Niegel Beechey

DESIGNERS:
Niegel Beechey,
Agnieszka Rozycka

CLIENT:
Acuiti Legal

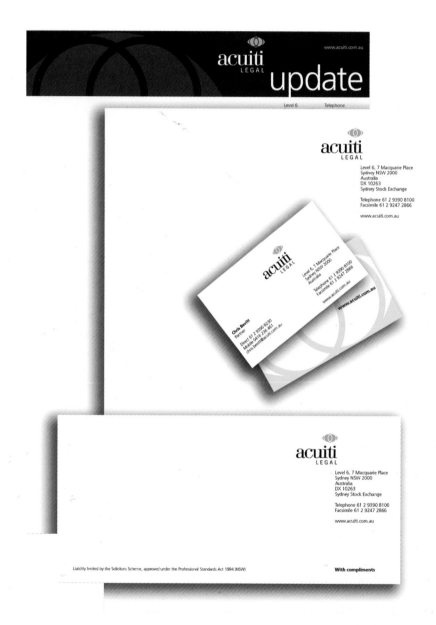

LEFT: Acuiti Legal's identity uses a modern color palette of orange and black—very non-traditional—and is itself a bold graphic depiction of the brand's personality and values, say designers.

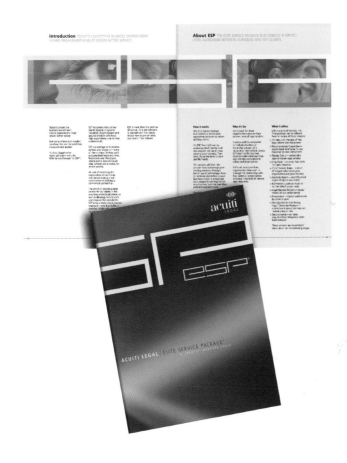

LEFT: Acuiti Legal's Elite
Service Package brochure
was created for premium
clients with a basic
service-level agreement.

BELOW: The Latin origins of
Acuiti Legal's name help
to reinforce and respect the
profession's academic tradi-
tions, its professionalism,
and heritage, say designers,
despite the fact that the
new identity breaks with
numerous legal traditions.

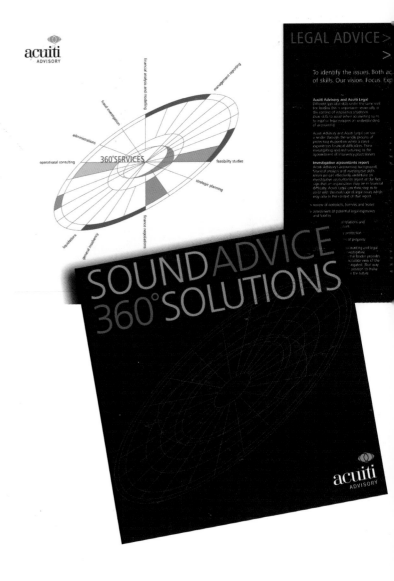

The Process

Middleton Moore Bevins was among Australia's most successful
and highly regarded legal firms, with more than thirty years in
the business and boasting offices in Melbourne and Sydney. In
2001, the thirty-year calm was about to be broken when the
Sydney partnership decided to split from its sister office and
establish a new identity that better suited its work as a specialist
in contemporary legal practice.

CPd was brought on to cut the branding ties that bound the
Sydney office to Melbourne, which required a total redesign of
the firm's corporate identity from name and logo to corporate
literature, signage, and Web site.

"The key objectives were to create a totally new identity
comprising a wordmark and graphic that while expressing
the brand's values of innovation and forward thinking, could
express the credibility and security expected from a professional
services firm," says Chris Perks, CPd. "The decision to separate
from the Melbourne partnership gave the Sydney operation an
opportunity to communicate a newer, sharper image, which
appropriately and relevantly reflects the business' direction."

Designers started work immediately on renaming the firm. They held a series of internal workshops that led them to choose Acuiti as the name that had the potential to communicate the firm's new positioning. "The word evolves from acuity, meaning sharpness, perception, and clarity of vision, which was then respelled to make it ownable and protectable," Perks says.

Designers set the name, Acuiti, in lowercase Bodoni and added the word "legal" to clarify its field of expertise and avoid the confusion that comes from a name that isn't explicit in defining the service it represents. This was particularly important in the legal profession, where traditionally, a firm adopts the surnames of the founding partners. Acuiti Legal broke with all tradition when it avoided this rule of the law— a deliberate move that gives the firm a certain panache that a broader market base might find appealing.

The logo is composed of two elements—the wordmark and a stylized image of an eye with overlapping pupils. Why a graphic icon of an eye? "It was created as the graphic identity to express partnership, and as a metaphor for shared vision," explains Perks. "It draws its inspiration from the brand's values of intelligence, daring, passion, flexibility, and focus—the latter also being expressed in the new name."

Moreover, the eye icon conveys that Acuiti Legal is focused. "Acuiti Legal is an industry focused legal firm versus partner focused; the people that make up the business share a common vision, tied together by a common set of values; these qualities highlight Acuiti Legal's forward thinking and vision for the business' direction," says Perks.

ABOVE: The Web site is multilayered and information filled, yet it is easy to navigate and not overly intimidating.

ABOVE: Individual icons were created for both Web and print use to differentiate Acuiti's core areas of expertise.

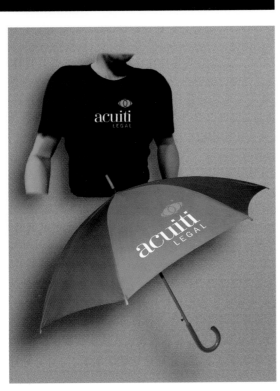

LEFT: Promotional items, including a T-shirt and umbrella, were created with the new mark, which is distinctive for its bold orange eye—an icon that conveys the focus of the firm.

RIGHT AND BELOW: These
brochures feature general
corporate profile documents
targeted to new clients,
along with a general outlines
of Acuiti Legal's services
and how Acuiti is different
from other law firms.

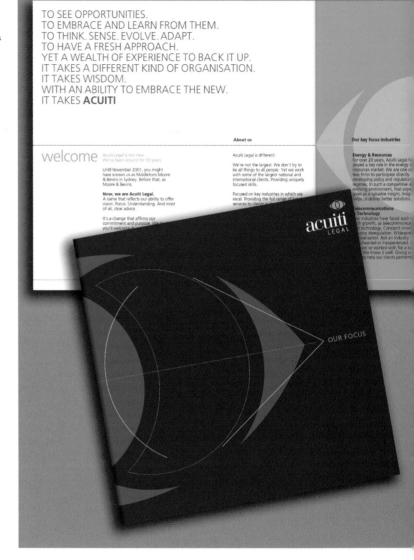

TO SEE OPPORTUNITIES.
TO EMBRACE AND LEARN FROM THEM.
TO THINK. SENSE. EVOLVE. ADAPT.
TO HAVE A FRESH APPROACH.
YET A WEALTH OF EXPERIENCE TO BACK IT UP.
IT TAKES A DIFFERENT KIND OF ORGANISATION.
IT TAKES WISDOM.
WITH AN ABILITY TO EMBRACE THE NEW.
IT TAKES **ACUITI**

"The use of the color orange works to differentiate Acuiti Legal from the sector's
more traditional parameters," adds Perks. "The graphics have created a visual
differentiation for the Acuiti Legal brand uncommon in the legal sector. Instead,
firms are usually represented using partners' names, rarely if ever using graphics
in conjunction with their wordmark. The color palette, too, lends itself to comment,
as it is bold and contemporary and a refreshing departure from the traditions of
the sector.

"Acuiti Legal's newly created identity represents a departure from the traditional
treatment of other identities in this sector. By virtue of this alone, the identity—
wordmark and graphic icon—stands up boldly and is clearly differentiated from
its competitors."

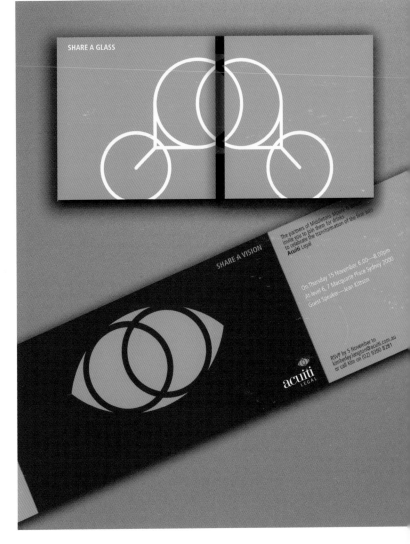

What Works

"The identity is a reflection of the new breed of legal firm—human, contemporary, energetic," Perks say. "The use of color, selection of type, and inclusion of a graphic element, all combine to reinforce their individuality in a traditionally conservative marketplace."

The identity debuted in November 2001 to unanimous approval from the partnership. According to CPd, reaction from Acuiti Legal's clients and new business prospects has also been very positive. The launch of the new brand proved so successful that Acuiti Legal's associated financial planning practice decided to adopt the same identity.

7·24 Solutions:
Anytime, Anyplace Graphics

DESIGN FIRM:
Ove Design &
Communications

ART DIRECTORS:
John Furneaux,
Jeffrey Vanlerberghe

DESIGNER:
Steven Pain

PHOTOGRAPHER:
David Graham White

CLIENT:
7·24 Solutions

7·24
solutions

Anytime, Anywhere,
eBanking, eBrokerage
and eCommerce

www.724.com

7
24

SOLUTIONS

FAR LEFT: The new logo
features multidirectional
arrows energized with the
color red. They act as a
visual metaphor for the
company's message of
'anytime, anywhere, on
any device.'

LEFT: The firm's original
logo said nothing about
its services.

ABOVE: Designers created
a special phone packaging
for 7·24 Solutions.

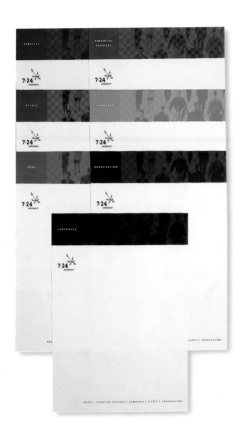

LEFT: Letterhead, created for each message the company needed to convey, was color-coded for differentiation.

"As a new company, 7·24 Solutions needed its corporate brand to communicate a breakthrough in a new category with an innovative offering that was not well understood by its potential client base. While the company had the products to effect real change in wireless communications, it was taking a functional, technology-based approach to selling its offering, which did not provide customers with a clear understanding of fundamental changes that were taking place in their businesses. Our objective was to help communicate the value of 7·24 Solutions in a way that would generate excitement about the company and widespread acknowledgment of its new technology."

The Process

7·24 Solutions is a high-tech company offering Internet services to the financial industry. When it approached Ove Design & Communications, it was sporting an identity that was neither practical nor supportive of the company's positioning. "Its busy design and small details did not lend itself to reproduction at small sizes—an important consideration, particularly in the high-tech industry where logos often need to work on-screen or in conjunction with other partner logos. It also failed to convey what 7·24 Solutions did or reflect its character as an innovative, thinking company," says John Furneaux, art director, Ove Design & Communications.

BELOW: Graphics are clean and the message is minimal; communications—like this folder for informational pieces—are kept to the bare essentials.

LEFT: This truly is a virtual company, with only its logo and Web address noted on its corporate letterhead.

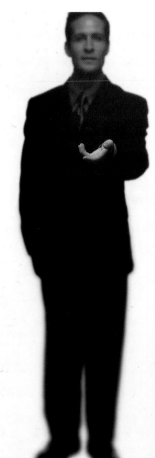

7·24
solutions
LIVECLIPS

Be at the center of your customers' universe

When your customers can see all of their important information in one place – your place – there's no reason for them to look anywhere else. At 724 Solutions we offer the most comprehensive wireless financial services solution in the industry and with our LiveClips™ aggregation offering, you become the window to your customers' mobile financial and information world.

LiveClips lets you provide your customers with a secure, convenient way to simply access all of their critical accounts in real-time, from virtually any network or device, without them ever having to leave your site. Wherever they want, whenever they want, on whatever device they choose, with 724 Solutions' LiveClips, you are the hub of your customers' Internet activity.

Designers went to work, starting by developing a call-to-action approach to its branding that would convey how the company's technology creates the potential for financial communications and activity at any time, in any place, on any device—seven days a week, twenty-four hours a day. "We transferred the company's messages and visual style, creating a new logo, positioning, and attitude that would enable 7·24 Solutions to challenge convention in the banking work without sacrificing credibility," says Furneaux.

"By clarifying how the Internet and wireless communications were continually changing the customer-business relationship for financial services, we helped position the company on the leading edge of change —poised to capitalize on the new environment and able help other businesses capitalize as well."

At the heart of the identity is its multidirectional red arrow logo. It is the constant that shows up on dozens

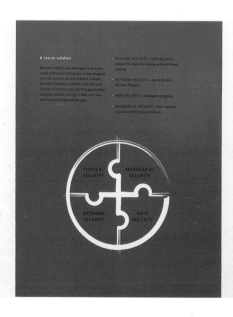

of pieces as the constant reminder of a company that is spinning off into multiple directions. "Firstly, it was a visual representation of the promise of 'anytime, anywhere, on any device.' Secondly, it supported the marketing positioning of 'Your Customer is in Motion.' And lastly, it was a reflection of 'chalk-talk' brainstorming, and the limitless thinking that is critical to the success of a technology company," explains Furneaux.

Furneaux continued, "Every aspect of the new brand—its name, identity, tone, and style—reflected a company that was at the forefront of change in the existing financial services sector. By making clear that there was a revolution underway in the industry and that customers were now in control of when, where, how, and with whom—they do their banking, 7·24 Solutions positioned itself as the company that would enable financial institutions to adapt to the new realities of the financial services landscape. Designed to be provocative without being brash, the visual identity and style enabled 7·24 Solutions to stand out in a crowded industry in a way that was meaningful to the marketplace."

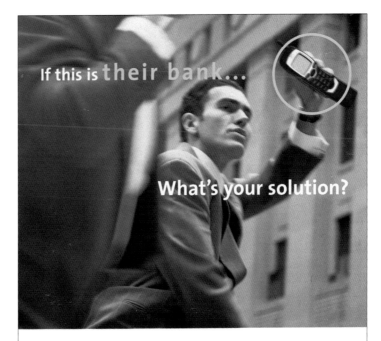

If this is their bank...

What's your solution?

Once people used the phone to **call** their bank. Now, all over the world, the mobile phone **is** their bank...and their brokerage...and their favourite store.

To keep connected to your customers, you will need to **go** to them. On whatever Internet devices they choose, whether it's WAP phones, PalmPilots or two-way pagers.

With 724 Solutions, you can do this today. Our solutions serve an addressable e-banking market of over 150 million people through partnerships with leading global banks, device makers and carriers.

If you're thinking about banking and mobile phones, use one to give us a call at +(612) 9006·1000.

WAP Member www.724.com 7·24 solutions

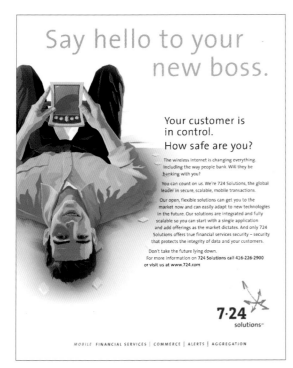

Say hello to your new boss.

Your customer is in control.
How safe are you?

The wireless Internet is changing everything. Including the way people bank. Will they be banking with you?

You can count on us. We're 724 Solutions, the global leader in secure, scalable, mobile transactions.

Our open, flexible solutions can get you to the market now and can easily adapt to new technologies in the future. Our solutions are integrated and fully scalable so you can start with a single application and add offerings as the market dictates. And only 724 Solutions offers true financial services security – security that protects the integrity of data and your customers.

Don't take the future lying down.
For more information on **724 Solutions** call 416-226-2900 or visit us at www.724.com

7·24 solutions™

MOBILE FINANCIAL SERVICES | COMMERCE | ALERTS | AGGREGATION

Think where mobile financial services are headed.

Now think again.
And again.

Mobile financial services will be going wherever customers want and wherever technology allows. About the only thing you can really count on is that things will change constantly.

Cover all the angles with 724 Solutions.

We are experts in deploying technologies that deliver secure, mobile financial transactions, from commercial and retail banking to equity trading and portfolio management. We are also experts in enabling mobile customers to manage financial and personal information through account aggregation and user-driven alerts.

Our open, flexible platform can get you quickly to market today, and can easily accommodate tomorrow's new technologies. Our solutions are integrated and fully scalable. So, you can start with a single application and add services as you see opportunity to lead your market. Our proven, FI-grade security protects both the integrity of data and the trust of your customers.

You can go mobile with great confidence because our solutions are already operating in some of the world's leading financial institutions.

Be prepared for whatever comes your way.

For more information on 724 Solutions call 416-226-2900 or visit us at www.724solutions.com

7·24 solutions™

MOBILE FINANCIAL SERVICES | COMMERCE | ALERTS | AGGREGATION

THIS PAGE: "Your Customer is in Motion," that's why you need a company that delivers service anytime, anywhere, on any device. That's the message in all the communications, as shown here on the cover of 7·24 Solutions' pocket folder and core brochure.

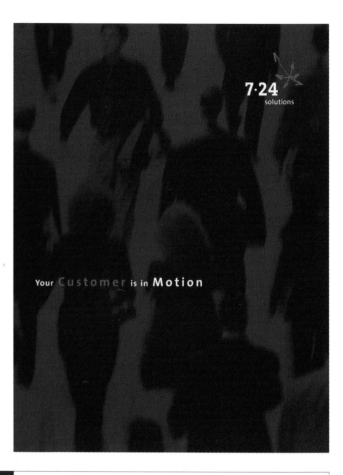

7·24 solutions

Your **Customer** is in **Motion**

Designers added thought-provoking questions to marketing materials and featured them prominently to guarantee that 7·24 Solutions' message reached its market and wasn't buried beneath copy overloaded with details. Simple graphics and illustrations keep the balance of the design clean, and once again, complement without detracting from the primary message. Admittedly, designers chose traditional corporate colors of blue with a splash of red because they wanted to project a sense of stability and credibility. They pulled this off without appearing staid by coloring the logo design a fire engine red.

The Internet offers financial services providers unprecedented opportunity to deepen relationships with their best customers. And it's their online customers who are, as a group, the best.

The new Internet also opens the door to a wave of software, ISP and portal competitors. Whoever moves early and decisively will have a clear advantage in capturing the customer.

However, in the digital marketplace, it's not the bank or brokerage who owns the customer. It's the customer who owns – or adopts – the company. The future belongs to those who swiftly turn this insight into action.

Be in the **Palm** of Your **Customer's Hand**

"Our partnership with 724 Solutions kickstarts our entry into wireless delivery of financial services worldwide. Citigroup has 100 million customers and we're building toward a billion by offering them our services when they want it, where they want it and how they want it."

Ed Horowitz
Senior Officer, Citigroup and head of e-Citi

Your Online Customers Are Your Best

Jupiter reports that households with more than $50,000 in annual income made up 60% of the online banking households by year's end 1998. It reassures us that "wealthier households will continue to be the most common customers of online banking services." In 1998, 51% of online brokerage users had incomes exceeding $75,000.

In a matter of months, 'online' will no longer be synonymous with 'PC'. Early adopters of wireless financial services will likely be digital devotees. Seventy percent of devotees are college educated; their median income is $57,000 and 73% are optimistic about technology. One hundred percent of them are being chased by your competitors.

The Customer Will Call You, A Lot

How often do your best customers call you? Right now, real customers are using internet-enabled mobile phones for financial information or transactions *over two dozen times a week*. This kind of connection is key to keeping your brand front and center. It's also a catalyst for the ongoing reinvention of your business.

A challenge for banks and brokerages is that many services are purely transactional and thus engender little loyalty. The key to winning loyalty is to weave these generic transactions into a unique offering of high value services that reflect your brand, your value proposition and your customers' choices.

The centerpiece is the customer's profile, created not by you, but directly by the customer. It is the mechanism for accessing and managing a dynamic, financial and e-commerce universe. It holds all the relationships, all the activities, all the history. It is always there, no matter what device the customer uses: PC, wireless or digital TV.

The customer remains loyal to you because he has built his world on your platform. If you're first to the customer, you have the best chance of a lasting relationship and you'll create significant switching costs. You'll deepen that relationship by using the information you gather to offer highly relevant, timely products and services. You'll offer shopping discounts and special rewards made possible by your privileged position as an aggregator. You'll keep the customer by keeping him in command.

This is the world the 724 Solutions architecture is designed to support. This is your opportunity.

It's Open Season

The convergence of financial services upped the competitive ante. Now, there's an array of technology companies who want to leverage their relationships with your customers to enter your business. No customer seems safe.

What could illustrate this better than bill presentment? Its projected growth presents an opportunity for banks to strengthen customer relationships, or squander them. Research by Jupiter informs us that only 42% of consumers preferred that banks present their bills. This may be the thin edge of the wedge for non-traditional players. Thirty-seven percent of consumers preferred that their bills be presented by personal financial management software; 13% named AOL as the preferred presenter. Even portals earned significant mention.

The outcome of bill presentment – and similar areas – is still undecided. But, it will be determined within the coming year by those who are taking decisive action now. 724 Solutions can help you be one of them, and we can help you secure your customers against all comers.

9

ABOVE: A series of spiral-bound booklets was created to disseminate everything from press clippings to 7·24 Solutions white papers. Each features a different full-color photograph that complements the title of the booklet printed on a plastic overlay. Underneath, the basic letterhead shows through with its logo and Web address.

What Works

The bold logo that says this company delivers solutions seven days a week, twenty-four hours a day is dynamic and memorable.

"A compelling case for the company resulted in crucial partnerships with the world's leading financial institutions and equipment manufacturers —ultimately, paving the way for the most successful initial public offering in Canadian history," says Furneaux.

ABOVE AND RIGHT: Brochures and other communications materials give prominence to thought-provoking questions that get to the heart of the message without beating around the bush.

BlueBolt Studio:
The Fabric of a Mark

DESIGN FIRM:
Alexander Isley Inc.

ART DIRECTOR:
Alexander Isley

DESIGNER:
Liesl Hanson

CLIENT:
BlueBolt Networks, Inc.

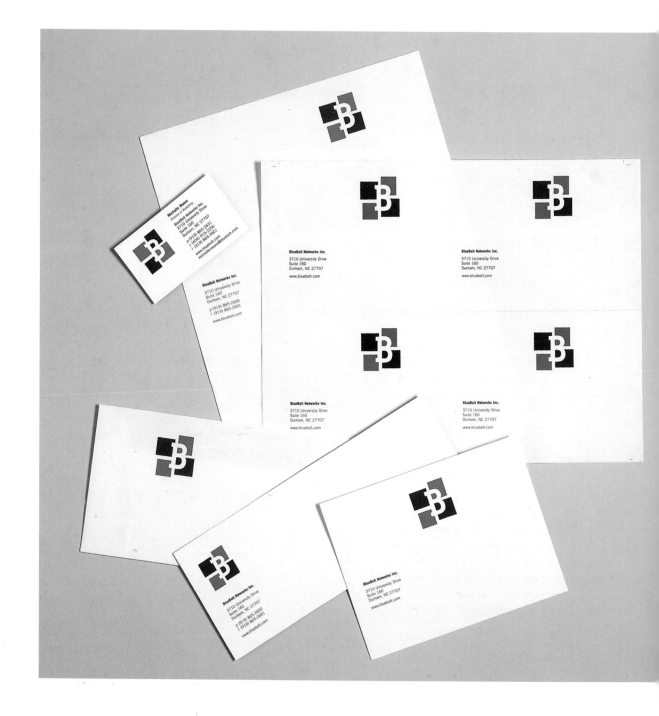

BlueBolt Networks, Inc.
P.O. Box 9323
Chapel Hill, NC 27515-9323

Alan S. Kabus
Chief Executive Officer
888.383.8749 phone
919.929.5992 fax
ASKabus@blueboltnetworks.com

BlueBolt
NETWORKS

The Process

BlueBolt Networks, Inc. makes materials specification software that is used by architects and interior designers. The product lets users compare, specify, and order materials online. No longer do architects and interior designers need to rely on cumbersome sample boards; now they can prepare boards by dragging and dropping samples onto digital boards. There, they can organize and arrange them, and add their comments before e-mailing them to a client or prospect for review. Once materials are approved by a client, users can order samples online and know that the product imagery accurately depicts the color, pattern, texture, and scale of the materials.

The identity that was in use didn't live up to this ingenious product. It didn't reflect the nature of the business and it lacked impact. Given the fact that it was never used on anything more than the company stationery and its Web site, BlueBolt decided to start over and retained Alexander Isley Inc. to update the old identity, develop a new product name, logo/mark, brochure, packaging, trade show booth, trade advertising, and e-mail blasts.

RIGHT AND BELOW: The logo and the familiar board-layout of swatches, which inspired the logo, is prominently featured on the cover of BlueBolt's press kit folder and throughout its letterhead system.

"The challenges were to introduce a product to a technology-resistant, skeptical audience; inform the public of the new category, establish BlueBolt Networks with a unique, creative approach, create a brand personality, and position products within the marketplace," says Alexander Isley of the task before him.

Designers chose the name BlueBolt Studio for the product—which suggested a workplace and a studio, they found a word that both architects and designers could relate to. Now that the name alluded to the product, designers felt that the next step was to develop a graphic mark that also spoke to the company's products and service.

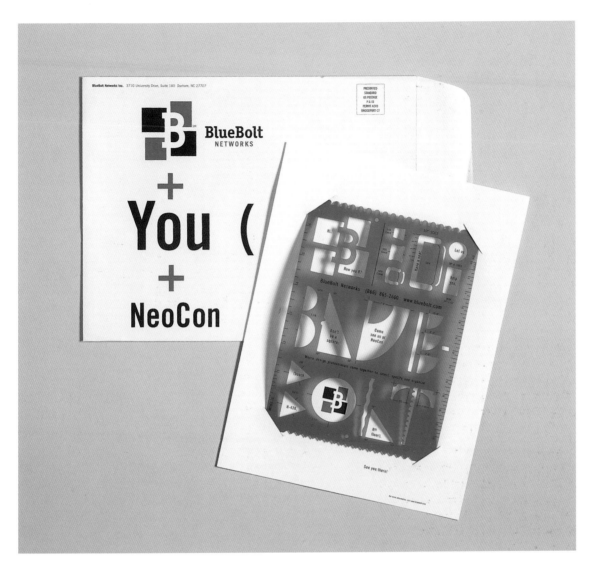

LEFT: Isley's comprehensive work for BlueBolt included everything from its stationery, brochures, and packaging.

BELOW: Since BlueBolt Studio's software is used to create sample boards where end-users adhere material samples and swatches to a board in harmonious groups an illustration depicting that work-in-progress was the most appropriate choice for the product packaging.

The software is used to create sample boards where one typically adheres material samples and swatches to a board in harmonious groups—such as colors for the living room, including carpet, paint, tile, wallpaper, upholstery, and fabric—with many of the swatches overlapping to demonstrate their compatibility. Designers came up with an icon that does this same thing—a pattern of four squares with a capital B overlaid.

"The new design works because it is memorable, friendly, and has a collegial look with attitude and tone and is also design-forward," says Isley. "The logo mimics the way materials are specified. It is successful because the application is consistent, not a rigid graphics program but rather, a consistent sensibility."

BlueBolt NeoCon Booth Development
Not to Scale/Not for Construction

colored company name sign; material TBD

custom logo signs along back wall; depth of each logo panel approx. 1 foot; each structure moves independently with wheel base

stripes along top strip; strip is 8" high

the strip should actually be lower if drawn to scale; to see all booth elements, the ceiling has been raised. The dotted red lines for reference are closer to actual in relation to rest of drawing.

Each black panel to be covered with a black BlueBolt supplier material; Each blue panel to be covered with a blue BlueBolt supplier material. Material source TBD.

H-426

arrow sign directs traffic toward center opening

custom floor color and material TBD

custom dividers and monitors with risers for demo presentation in "massage station."

custom floor color and material TBD.

main display table

custom low benches along front and side of exhibit space for seating and to direct traffic toward center opening; to be covered in BlueBolt supplier fabric; material TBD.

tables and seating, monitors for viewing demonstrations if needed

custom refreshment bar/storage area; will need custom shelving along front face for storage of company literature, etc.

exhibit booth I.D. used at least once along top strip.

BlueBolt Net

Date: 4/11/01

Scale: NTS

Alexander Is
4 Old Mill Road
Redding, CT 06¦
(203) 544-9692
Fax (203) 544-7

The single most important element in the new identity, according to designers, is their decision to position BlueBolt as a trusted colleague. "Everything—the look of the pieces, the attitude, copy—stems from that position," says Isley.

Isley's work for BlueBolt was comprehensive; it included everything from its stationery, brochures, and packaging to an elaborate trade show booth. Who wouldn't want to stop by BlueBolt's new trade show booth that is complete with a massage area as well as a tea bar?

What Works

"There is spiritedness and a flexibility that is also referential to the actual materials selection process," says Isley. "[The identity is] design forward, but friendly, bold, and powerful, but flexible. [It's] is memorable because the actual process it evoked."

The identity definitely stayed top of mind with it's target market. Following the launch of the new campaign, BlueBolt recorded an increase in both customers and suppliers wanting to be represented in the software.

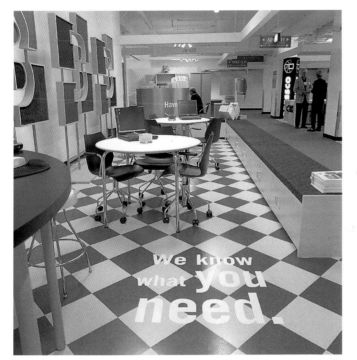

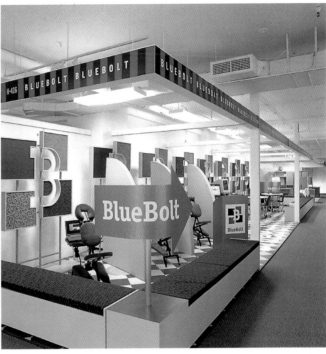

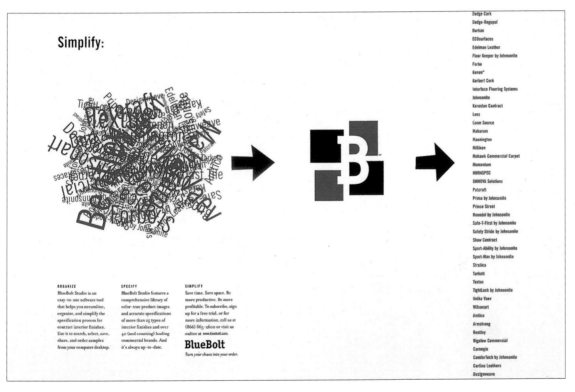

Simplify:

Dodge Cork
Dodge-Regupol
Durkan
ECOsurfaces
Edelman Leather
Floor Keeper by Johnsonite
Forbo
Genon®
Gerbert Cork
Interface Flooring Systems
Johnsonite
Karastan Contract
Lees
Loom Source
Mahpram
Mannington
Milliken
Mohawk Commercial Carpet
Momentum
MIRASPEC
OMNOVA Solutions
Patcraft
Prima by Johnsonite
Prince Street
Roundel by Johnsonite
Safe-T-First by Johnsonite
Safety Stride by Johnsonite
Shaw Contract
Sport-Ability by Johnsonite
Sport-Max by Johnsonite
Stratica
Tarkett
Textos
TightLock by Johnsonite
Unika Vaev
Wilsonart
Amtico
Armstrong
Bentley
Bigelow Commercial
Carnegie
ComforTech by Johnsonite
Cortina Leathers
Designweave

ORGANIZE
BlueBolt Studio is an easy-to-use software tool that helps you streamline, organize, and simplify the specification process for contract interior finishes. Use it to search, select, save, share, and order samples from your computer desktop.

SPECIFY
BlueBolt Studio features a comprehensive library of color-true product images and accurate specifications of more than 25 types of interior finishes and over 40 (and counting) leading commercial brands. And it's always up-to-date.

SIMPLIFY
Save time. Save space. Be more productive. Be more profitable. To subscribe, sign up for a free trial, or for more information, call us at (866) 865-2600 or visit us online at www.bluebolt.com.

BlueBolt
Turn your chaos into your order.

ABOVE: "Organize. Specify. Simplify," proclaims this ad for BlueBolt Studio that lists all of the materials suppliers it represents. After the launch of the campaign, BlueBolt reported an increase in suppliers wanting to be represented in the software.

A Look Back

Litho Press Inc.:
Evolution of a Logo

DESIGN FIRM:
Lodge Design Co.

DESIGNER:
Eric Kass

CLIENT:
Litho Press Inc.

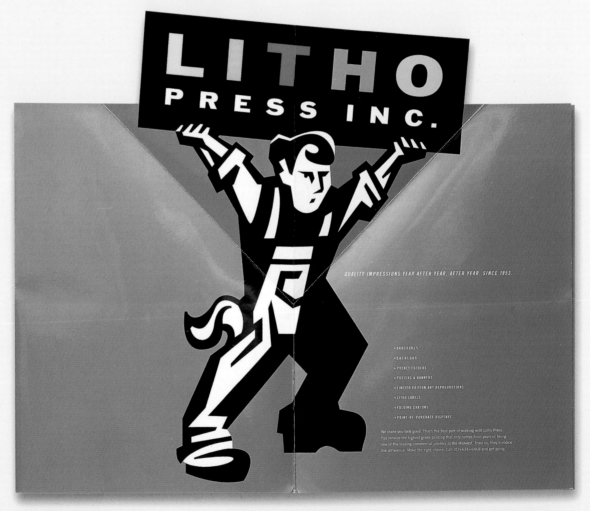

ABOVE: The presentation folder opens up to reveal a pop-up diecut of the pressman rising from the crease to present the Litho Press Inc. brand.

Litho Press Inc. is now on its third identity. In 1965, it introduced a bull's eye styled logo and used it until 1987 when it launched a color bar logo. "The old strip logo doesn't say anything specific about the personality of the company. You could plug any company name in and it would work the same. It is very easy to forget," says Eric Kass, Lodge Design Co., who was given the task of developing a new logo for 2000. "Being extremely horizontal makes it difficult to use on varying applications and the multitude of colors translate poorly into black and white."

RIGHT: The bull's-eye logo debuted in 1965.

LITHO PRESS, INC.

LEFT: This chain-of-squares logo was used from 1987 to 2000.

Litho Press needed a new logo that was not just memorable, but could be used over a variety of applications. Kass developed multiple comps, many using six colors to highlight the printer's expertise in six-color printing. These also used the four process colors and spot colors to drive home a point, but while the designs sported pretty colors, they didn't come close to communicating the company's strong Midwestern work ethic and years of printing expertise the way the chosen logo did—a mark featuring a pressman hoisting the company's nomenclature above his head.

While the logo is printed in six colors, it was first created in black and white to ensure it worked just as well in one-color applications.

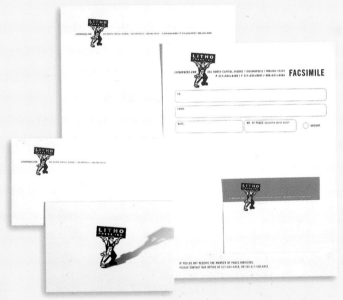

LEFT: The logo is flexible enough to work on a variety of applications ranging from the letterhead system to shipping cartons.

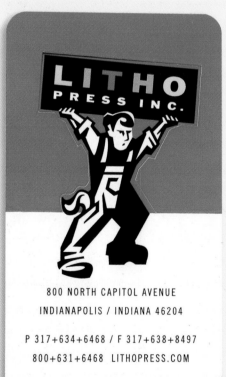

"It is very memorable and fun. It immediately expresses the company's experience and strong work ethic. It also reproduces well on everything from shipping boxes and pens to building signage and delivery trucks," says Kass. "All of the elements work together to create the message, but I personally like the handkerchief best. It speaks to the craft of printing. The roll up your sleeves, wipe the sweat from your brow art of offset lithography that has been practiced for decades at Litho Press Inc."

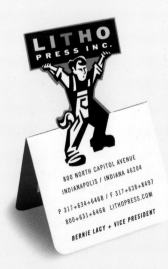

LEFT: A fold and a diecut allow the business card to be placed on a desk with the pressman at ready attention "for easy access to decades of printing expertise."

Entertainment

Anything goes when you're marketing entertainment. Right? It might seem so if you judge the question based the marketing of today's movies, concerts, television shows, and music videos. The truth is that designing sales tools that entertain does give creators considerable leeway. After all, designers are creating for an industry that sells excitement, escapism, and sex appeal.

Are there rules? Absolutely. In the following pages, we'll track the evolution of brand identities for entertainment companies that sell everything from operatic performances and radio shows to high-end, interactive DVDs and Christian Webcast broadcasting.

In each case, designers are marketing entertainment—a dream come true—for many who feel restricted by tight corporate design codes that apply to everything they create. It may surprise them to discover the restrictions and limitations that these "free-wheeling" creators work within: Marketing venues are often temporary, so signage must be portable and easily installed and torn down. There are rules about credits and debate over whose names goes on top to the point that copy must conform to a set hierarchy. Performances and subject matter change dramatically and identities must be flexible enough to adapt to any topic. And these are just a few of the constrictions placed on designers.

Nevertheless, despite the challenges, the design teams profiled on the following pages love their work and have proven once again that what Ethel Merman sang is true: "There's no business like show business!"

CBC Radio 3:
Words and Music

DESIGN FIRM:
Faith

**ART DIRECTOR/
DESIGNER/
ILLUSTRATOR:**
Paul Sych

PHOTOGRAPHERS:
Rob McLaughin, Tatiana
Nemchin, Don Pennington

CLIENT:
Canadian Broadcasting
Corporation (CBC)

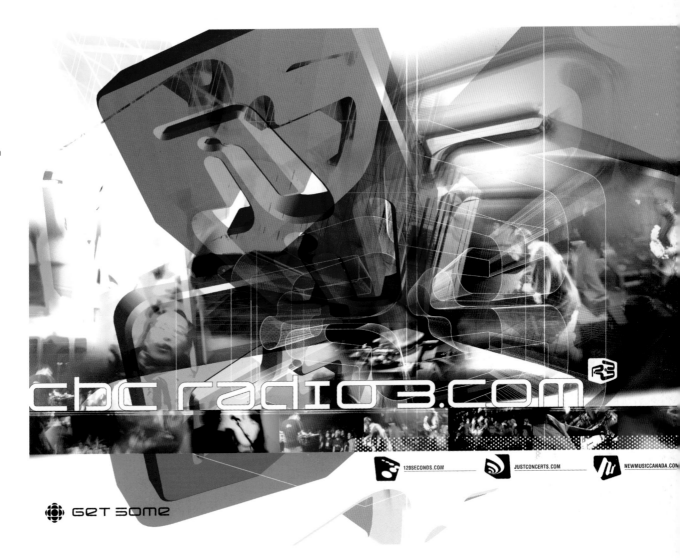

ABOVE: **Sych delivered upon the
client's request that the identity
inspire youthful imagination. He
fulfilled Radio 3's request in all
the identity elements, but perhaps
it is most evident in this poster
that exemplifies today's sixteen-
plus generation that enjoys art
and entertainment where multiple
images or events take place
simultaneously as the imagery
does in this poster.**

The Process

The Canadian Broadcasting Corporation (CBC) approached Paul Sych, whose firm, Faith, accepts comprehensive graphic design, advertising, and typographic assignments. Combine Sych's love of typography with his background as a jazz musician, and his firm was the perfect choice to develop a new identity for CBC's Radio 3 and its four main Web sites—New Music Canada, 120 Seconds, Just Concerts, and Radio Sonic.

The client requested that Sych take a thematic approach to its brand package that would be the common thread linking the parent brand, Radio 3, with its subbrands, and would lend itself to retail applications, as well as the Internet and print graphics, including Web sites and advertising that would all motivate its trendsetting market of teens over sixteen to tune in.

Because Sych specializes in custom type, developing a custom type logo was a natural extension of the client's request for a thematic brand package. He set about creating a very edgy, fluid, and futuristic treatment of an *R* and the numeral *3* to communicate CBC Radio 3, and placed the two elements in six-sided box. The result is a fresh, modern logo with a slight radical edge—perfect for appealing to its media-savvy target audience.

Next, Sych developed the logos for the subbrands, giving the same fluid, future-digital technique to the type, and framing each custom icon in a multisided box. "The new identity is successful because it marries all of the logo into a sequence," he says. "I thought of this approach as Radio 3's offspring and delivered them as a unit. The common custom font design helps this as well."

BELOW: Radio 3's business cards are printed with one side in grays and orange, while the reverse features the sub-logos of its Web sites. Likewise, the letterhead features the individual logos of the sub-brands in the upper right corner of a clean white slate of paper.

RIGHT: The two-pocket folder looks innocent enough on the outside, but beware. Open it up and the inside spread features Sych's dynamic logo treatment in black and white.

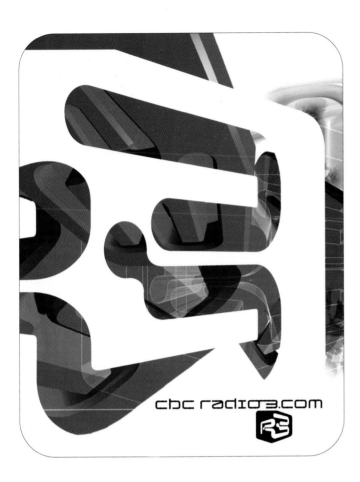

BELOW RIGHT: The CBC Radio 3 logo and sub logos for 120 Seconds, New Music Canada, Just Concerts feature Paul Sych's cutting-edge custom type treatment framed in multi-sided boxes.

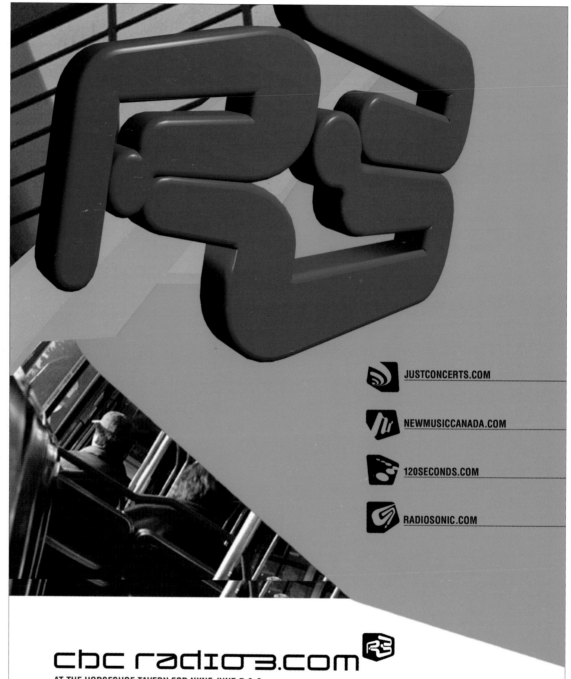

JUSTCONCERTS.COM

NEWMUSICCANADA.COM

120SECONDS.COM

RADIOSONIC.COM

cbc radio3.com

AT THE HORSESHOE TAVERN FOR NXNE JUNE 7, 8, 9
RADIO2 LIVE – JUNE 9, 10 PM-MIDNIGHT ON 94.1 FM TORONTO
HOSTS MARY-ANNE KOROSI AND JAMES GRAHAM
ON THE WEB LIVE – JUNE 9, 10 PM-MIDNIGHT ON WWW.JUSTCONCERTS.COM

Sych subsequently carried the imagery, including the
individual icons, through each element in the system
from the business cards, letterhead, folder postcards,
ads, and posters, which feature the icons as three-
dimensional elements that appear as if they are
floating in space.

Ask Sych what the single most important element is in
the overall design and he answers without hesitation:
"The custom font design and icon design." Why?
Because "it seemed the right thing to do."

"The graphics are a contributor," he adds. "The graphic
components mirrored a sense of playfulness using
the icons as a graphic device. Graphics enforcing the
brand—in very much the way it was designed—to
promote imagination."

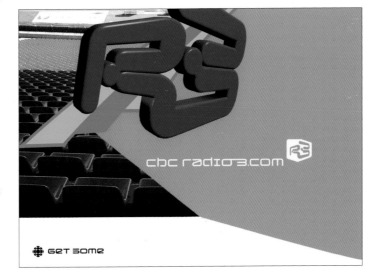

What Works

"The graphics appeal to the marketplace," says Sych, suggesting that by using shape,
depth, and a sense of playfulness, they work effectively and also meet the client's
request for an image that inspires youthful imagination.

The new identity is also inspiring plenty of awareness, too. To date, Radio 3's new
identity has been very well received by a young, and "in an uncanny way, by an older
audience as well," adds Sych.

Canadian Opera Company:
Setting Type to Music

DESIGN FIRM:
Riordon Design Group Inc.

ART DIRECTOR:
Ric Riordon

DESIGNERS:
Dan Wheaton, Shirley
Riordon, Tim Warnock

PHOTOGRAPHER:
Johnny Eisen

CLIENT:
Canadian Opera Company

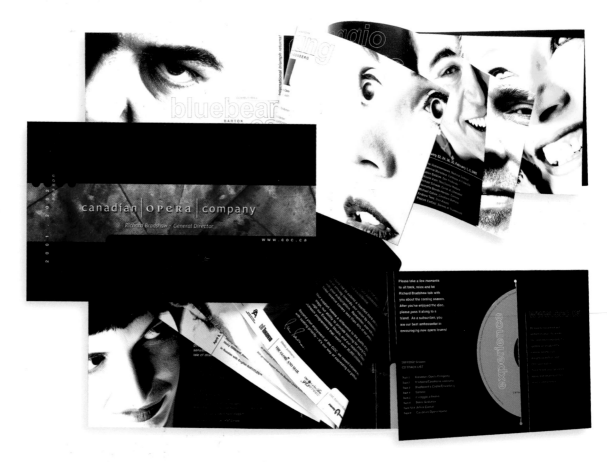

ABOVE: **To give contrast to
the all type logo, designers
chose to use stylized
photography. For the 2001
COC season, designers
colored the photography
with shades of purple, red,
blue, green, and yellow, and
placed the photos against a
black background. The total
package raised the image
of the COC and portrayed
it for what it was—a con-
temporary, innovative, and
sophisticated organization.**

The Process

The Canadian Opera Company didn't have a standards manual, so everyone with a
hand in producing promotional material took liberties with the logo now and then
if they thought it made their project look better. Others found the logo embarrassing
—out of date and alien to what the COC was all about—so they avoided using it
completely. Realizing that their identity was in need of a makeover that would be
accepted by everyone and be in tune with what the organization was doing, the
Canadian Opera Company tapped Toronto's Riordon Design Group for advice.

"We wanted to design a foundation typographic wordmark that would set the style,
tone, and manner for all of the communications material. Something that reflected
the nature of the organization and that would perform as a key branding element for
the Canadian Opera," says Ric Riordon about the firm's initial thoughts on the proj-
ect. The final result is just what Riordon predicted—a typographic logo.

canadian | O P E R A | company

CANADIAN
OPERA
COMPANY

RIGHT: Advertisements for the Canadian Opera Company feature the typographic logo in a color band across the upper quarter of the ad. Bold type and moody photography portray the COC as contemporary and a leader in musical entertainment.

ABOVE: The Canadian Opera Company's original brand identity didn't have unflagging internal support. Liberties were taken with the design if it was thought to improve the project and some avoided it entirely because they were embarrassed by the fact that it no longer portrayed what the COC was all about. With no standards manual in place, there were no rules to how the logo should be used.

"The nature of the organization is subtly featured by contrasting the word 'opera' in all capitals sandwiched between Canadian and company in lowercase. The stylizing of the typographic 'opera' hints at the classic heritage element and brings particular emphasis to the nature of the organization," explains Riordon. "It works because it is modular, bold, legible, and simple. It works well in differentiating visually from a number of backgrounds; it scales well at large and small sizes—both online and in print applications."

RIGHT: The COC was so happy with the results of the 2001 branding program that they came back to the Riordon Design Group for their 2002 promotional campaign. Once again, designers used photography to offset the all-type logo, but this time, they chose to color the photos with a sepia tone and a warm palette of colors for a rich look that communicates the heritage of the COC.

SUBSCRIBE & WIN!
Order your 2002-2003 season tickets online before May 10 and win a vacation from Austrian Airlines. >>

BORIS GODUNOV
The greatest of all Russian operas. >>
April 5, 9, 11, 14, 17, 20, 2002

JULIUS CAESAR
Ewa Podles and Isabel Bayrakdarian star in Handel's colourful masterpiece. >>
April 6, 10, 12, 16, 18, 21, 2002

NERVOUS ABOUT OPERA?
Don't be! Click here to discover more about the operatic experience.

Sign up for eOpera, our e-newsletter.

Canadian Opera Company
227 Front Street East, Toronto, Ontario, M5A 1E8
T 416.363.6671 F 416.363.5584 E info@coc.ca

canadian | opera | company

Richard Bradshaw ~ General Director

PERFORMANCES | TICKETS | THE COMPANY | EDUCATION | DONOR PROGRAMMES | MEDIA | NAVIGATE

ADULT ACTIVITIES
There is more to Education than just kid's stuff. Click to discover what we offer. >>

SCHOOL PROGRAMMES
Teaching students and teachers opera through a number of programmes and presentations. >>

COMMUNITY ACTIVITIES
Afterschool programmes and opera camps keep the kids entertained.

NERVOUS ABOUT OPERA?
Don't be! Click here to discover more about the operatic experience.

EDUCATION

Photo of Roger Honeywell and Krisztina Szabó in *Giulio Cesare in Egitto* (2001) by Michael Cooper.

PERFORMANCES | TICKETS | THE COMPANY | EDUCATION | DONOR PROGRAMMES | MEDIA | NAVIGATE

ALL: The Riordon Design Group updates the Canadian Opera Company's Web site to correspond with the seasonal promotions, revising everything from the home page to its page detailing educational programs and archive of past press releases.

canadian OPERA company [HOME]

MEDIA
Home > Media

Media

Click on the title to read our archived press releases.

PRESS RELEASES 2002

PRESS RELEASES 2001

PRESS RELEASES 2000

CONTACT PUBLIC AFFAIRS

Photo of Henriette Bonde-Hansen as Corinna in *The Journey to Rheims* (2002) by Michael Cooper.

PERFORMANCES | TICKETS | THE COMPANY | EDUCATION | DONOR PROGRAMMES | MEDIA | NAVIGATE

With the logo finalized, designers went on to develop collateral material for the COC including its annual brochure, signage, and Web site. To complement the wordmark, designers chose to use stylized photography. For the 2001 COC season, designers colored the photos in shades of purple, red, blue, green, and yellow. When they embarked on the 2002 COC season brochure, they opted for sepia-toned photography and a palette of warm, autumnal shades to distinguish the year's events. In each case, designers manipulated the images to portray the mood, personality, and experience of the Opera's productions for greater market appeal.

"The success of the identity is enhanced by images that underscore the same fundamental characteristics—contemporary, bold, sophisticated—as the true identity," adds Riordon. "The support graphics—type, photo images played a significant role in establishing a new look in their market."

THIS PAGE: The Riordon Design Group created signage for the Canadian Opera Company, which required large banners for display in the Hummingbird Centre in Toronto for both the 2001 and 2002 seasons. Portability was the primary design challenge, as the banners needed to be taken down and stored between performances; running a close second was the three-day turnaround time. Designers built the graphics at one-quarter scale in Adobe Illustrator, which was chosen because it facilitated scaling.

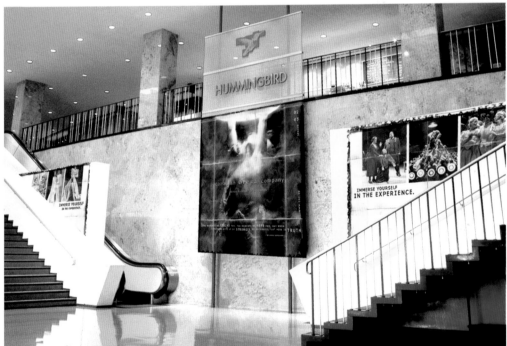

What Works

Despite a tough year, the Canadian Opera Company realized increased visibility, outstanding feedback from their client base, and an increase in subscriptions as a result of the new identity. Equally important, the client was sold on it and proud to use it everywhere, which provided the internal support required to successfully implement its application and potential from a branding standpoint.

lineonline:
Setting the Stage for an Event

DESIGN FIRM:
Rome & Gold Creative

ART DIRECTOR:
Lorenzo Romero

DESIGNERS:
Robert E. Goldie, Brandon
Muth, Lorenzo Romero

ILLUSTRATORS:
Lorenzo Romero,
Robert E. Goldie

CLIENT:
Calvary of Albuquerque,
Connection
Communications

ABOVE: The original stage is
the perfect contemporary,
nondenominational church
setting—clean, inspiring,
and uplifting, but to draw
crowds to a Webcast,
something more exciting
was needed.

The Process

Lineonline is a weekly, live Webcast production sponsored by Calvary of
Albuquerque and Connection Communications. When the client approached Rome
& Gold Creative for help turning its Webcast into an event, the look and feel of the
existing format and set was very traditional in every sense. The stage resembled an
altar in a contemporary, nondenominational church—clean, inspiring, and uplifting,
but not exactly what was needed to draw large audiences to a Webcast event.

Rome & Gold Creative's job was to create a logo that would distinguish the Webcast,
design the set, create a line of apparel, and a Web site—lineonline.net. "Our goal
for this logo was to promote and create awareness around their weekly Webcast
production. In creating this logo, it was our intention to develop a clean, simple
mark, which would work being placed on a variety of articles," says Lorenzo Romero,
art director at Rome & Gold Creative.

line⊙nline

BELOW: Because the @ symbol is so globally associated with the Web, it made perfect sense to make it the focal point in the logo, working as an Internet icon as well as representing the letter *o* in online.

"The client's transitional set design was a major contributing factor in the development of the identity. It was our desire to create an event utilizing a temporary stage set to transform the permanent stage."

With these objectives, designers set to work on the logo based on—of all things—the @ symbol that has become so associated with everything Web oriented. A modified version of the @ symbol appears in the center of the logo and works both as a symbol for the Web, as well as the letter *o* in online.

The result is the simple and clean mark that designers sought in their initial brainstorming sessions that would work as well on the stage as it would transfer to various items in order to promote the production from apparel to collateral.

LEFT: The stage is divided into a conversational area and an elevated deck for the band—similar to the setup used on most late night talk shows. The set is created with warm, high energy colors of red and yellow, derived from the logo color palette. The conversation area is complete with television monitors, couch, easy chairs, coffee table, plants, and a rug that mirrors the @ symbol in the logo.

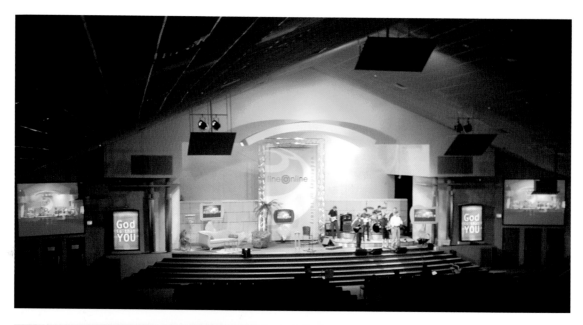

With the logo decided, designers moved onto the set itself. Using the red and yellow color palette from the logo, designers created a warm, dynamic set—entirely different from the cool tones of the traditional churchlike setting of the existing stage. A conversation area was integrated into the set, complete with television monitors, couch, easy chairs, coffee table, plants, and yes, even a rug that mirrors the @ symbol in the logo.

Not unlike late-night talk shows, an area of the stage is reserved for the band, which takes its place on an elevated deck on the opposite side of the stage.

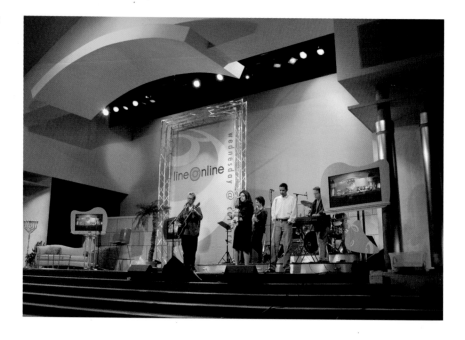

Flanking the sides of the stage are light boxes with messages to the audience—whether they are there in person or watching from home on the computer.

"The set was created to be conducive to an exciting multimedia experience live, in-person, or on the Web," says Romero. "The colors [and] shapes lend [themselves] to the inviting, high-tech production. The graphics transition well between various promotional articles."

What Works

"The graphic used created a retro, high-tech feel that reached the targeted demographic," says Romero. "Since March 2002, attendance on the night of the event has increased, and there's also been an increase in Web site traffic during the Webcast of the event."

ABOVE: Flanking the sides of the stage are light boxes that communicate messages to the audience—whether they are seated in the auditorium for the live show or watching from home on the computer.

ABOVE: T-shirts feature the broadcast's name, lineonline, as well as its logo.

Children & Education

Playful, colorful, fun; scholarly, traditional, conservative. Are these the adjectives we use to describe graphics targeted at children and students? Yes, they are and yet, the times are changing and so are the visuals that communicate to these audiences. Just consider how colleges and universities are changing the ways they market; scholarly, traditional, and conservative don't exactly sell the majority of high school students on where they will spend their next four years.

In this chapter, we'll look at graphics designed to talk to young people—children, teenage girls, youngsters ages six to fourteen, and college-bound teens. Of all the markets discussed in this book, young people may very well be among the most discriminating audiences when it comes to attracting and winning their attention.

Marketers must find where their loyalties lie. What wins them over? What inspires them to new heights? What are their aspirations? What do they do for fun? The answers to these questions may not even be known to their parents but are locked deep inside their psyches. So how does a graphic designer charged with developing an identity to appeal to this market find the answers? Get into their heads, as the design firms on these pages have done.

Young people are tough consumers. Price isn't an issue; how the product or packaging looks is everything. These consumers know what they like. They recognize instantly if something is passé. They set the trends and they are drawn to trendsetters.

Big Brothers Big Sisters of Central Iowa: Design Solutions Come in Pairs

DESIGN FIRM:
Sayles Graphic Design

ART DIRECTOR:
John Sayles

DESIGNERS:
John Sayles,
Som Inthalangsy

ILLUSTRATOR:
John Sayles

CLIENT:
Big Brothers Big Sisters
of Central Iowa

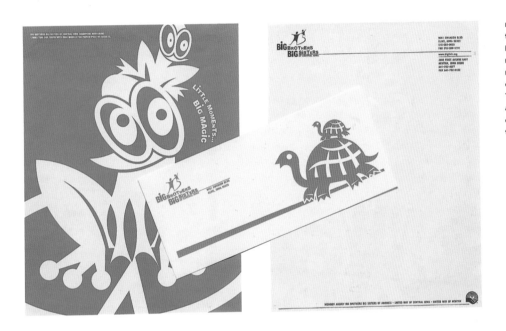

LEFT: Sayles retained the purple color for the letterhead but added bold neon colors to all other materials—printing everything in one color. The reverse may be another color, but two colors don't appear together on a single side.

The Process

"Big Brothers Big Sisters of Central Iowa is getting bigger" proclaims the organization's press release announcing its move to a new location. But before the organization started packing, they reexamined their identity and thought that the move might provide the perfect opportunity to update its identity. Sayles Graphic Design volunteered for the project, offering to create a new identity for the nonprofit Big Brothers Big Sisters (BBBS) that matches children between the ages of six and fourteen with an unrelated adult volunteer for role modeling, support, guidance, and friendship.

BBBS had previously used students to design its marketing materials; it was a low-cost method to getting materials out to the public, but it was a decision that compromised quality and consistency. When Sayles Graphic Design offered to do the entire project at no cost, it was a dream come true. BBBS needed everything but realized that priorities needed to be established in order to do first things first. Urgent needs included graphic-use standards, easy-to-use templates for newsletters and flyers that are produced inhouse, various visual elements needed at the new location, and invitations to special events.

RIGHT: Sayles liked the graphic portion of the original logo but felt that the type treatment was weak. It was inconsistent in its use of a font and sometimes the copy was stacked; sometimes it wasn't. Purple was the predominant color on all communications, which Sayles thought needed some added excitement.

John Sayles took charge of the overhaul, beginning with the logo. The graphic icon itself was good, but Sayles felt that the type treatment was weak. It was inconsistent in its use of a font and sometimes the copy was stacked, sometimes not. Sayles revised the logo, choosing to keep the graphic icon, but establishing a standard for the type, setting it in the same font—Arial—but integrating uppercase and lowercase letterforms to emphasize the organization's mission to match up "big" adults and "little" children. By mixing up the type as he did, he gave the logo personality and a childlike innocent appeal.

BELOW: Sayles reset the name of the organization in a consistent typeface —Arial—but integrated upper- and lowercase letters to emphasize the "big" and "little" mission of BBBS. He applied that same type treatment to the names of the organization's personnel and added the organization's mission statement to the reverse of the card with a bold splash of color.

Type was one of Sayles' creative tools; the other was color. The previous identity was one color throughout —purple. Sayles, kept the purple for the letterhead but added other bold colors to each succeeding element in the package so that at a glance, the identity appears as colorful as a box of Crayola crayons.

By printing on the reverse side of the business cards and letterhead, Sayles was also able to emphasize the organization's tagline—"Little moments, Big magic," which had been previously buried as a subservient element on collateral material.

ABOVE: The previous identity buried the organization's slogan, "Little moments... Big magic," or treated it as an afterthought, sticking it in anywhere it would fit into a layout. Sayles redesign gives the slogan prominence on almost every piece, including this postcard.

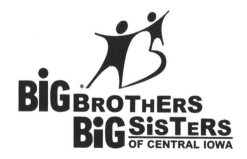

BEGIN IMMEDIATELY TO PUT A LITTLE MAGIC IN A CHILD'S LIFE AND HELP BUILD THE ASSETS THAT WILL DETERMINE HIS OR HER FUTURE.

COMMUNITY BASED MENTORING

The foundation on which Big Brothers Big Sisters was built, this program matches youth ages 6-14 with adult role models one-on-one for guidance, support, and unconditional friendship.

Bigs and Littles meet a couple of times a month to do things together such as go on bike rides, bake cookies, work on homework, surf the internet, and shoot hoops. It's flexible - you and your Little meet when it works for both of you.

Littles are matched with Big Sisters, Big Brothers, Big Duos, or Families. This program allows the Littles to shine as they grow and learn from their mentor(s) about relationships and develop to their full potential. We offer a professional and experienced staff to support your match and ensure a fun, fulfilling experience.

WHEN YOU WERE YOUNG, WHO IS THE PERSON WHO BROUGHT A LITTLE "MAGIC" INTO YOUR LIFE?

In our own lives, each of us was touched by someone other than our parents who broadened our horizons and brought a little magic into our lives. Becoming a Big Brother, Big Sister, Big Duo, or Family Match will allow you to do the same for a child. You will both be forever changed by this magical experience.

BUDDIES

Buddies is an exciting program for children waiting to be matched with a Big and for volunteers who want to try out the mentoring experience.

This 8 week program is offered three times a year; spring, summer, and fall. Big and Little Buddy matches meet on a specific night each week. The Buddies Coordinator plans exciting group activities around the community.

Children in this program enjoy learning about their community by taking part in a fun and educational recreation program. They also benefit from having a supportive friendship with a positive, caring adult. Volunteers enjoy the opportunity to be a kid again, forget their personal checklist, and just have fun! Check to see if this program is available in your area.

BIGS IN SCHOOL

This newest volunteer opportunity combines the expertise of two organizations. School personnel and the Big Brothers Big Sisters' coordinator provide an opportunity for volunteers to meet with a child at the school or other locations. Volunteers meet with their Little for 30-60 minutes a week during the school year. These matches work on school work, play games, and talk; all the while building a relationship and helping a child's self-esteem improve.

Students matched have fewer truancies, improved academic performance and improved relationships with peers and school personnel. The results are incredible! Check to see if this program is available in your area.

This slogan often appears hand-in-hand with original illustrations by Sayles, who has built quite a reputation for his hand-rendered illustrations. To dress up the system's components and add excitement, Sayles illustrated animals in much the same style as the logo's graphic icon. When he creates these types of illustrations, he first draws the images on tissue paper and then builds prototypes from hand-cut paper. In this case, he worked with his computer artist, Som Inthalangsy, to develop pairs of big and little animals—deer, fish, monkeys, and many others. Once integrated into the layout, he colored them the same hue as the type on the piece, choosing neon colors of orange, green, fuchsia, and blue that shout, "Look at me!" and are a dramatic departure from traditional nonprofit colors that speak much more quietly. While this system is rich with color, it is interesting to note that each piece is printed in one color, and on one side. Nothing is printed in two colors on the same side. "Naturally, we're watching the budget closely," says Sayles, "But it didn't change the cost to vary the ink colors, since we were printing a variety of materials on different print runs. It brings a whole new dimension and sense of fun to the program."

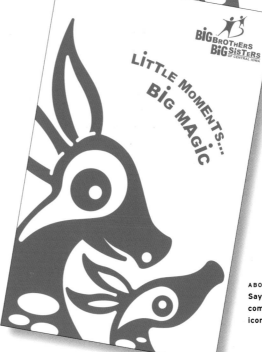

ABOVE: **The illustrations Sayles created perfectly complement the graphic icon in the original logo.**

LEFT: **Sayles, who is known for his illustrations, created a series of big and little animal pairs from monkeys, deer, fish, and birds and placed them on notecards and other marketing materials again to emphasize the fact that Big Brothers Big Sisters matches children up with adult mentors.**

RIGHT AND BELOW: A palette of neon colors was used throughout the package, so when Sayles created a sheet of graphic standards for BBBS to follow internally, he listed acceptable typefaces, paper colors, Pantone inks, and supplied a variety of the illustrated animal pairs to use instead of clip art.

Establishing graphic standards and templates for internal use were among the next items on Sayles' agenda. He didn't prepare anything fancy as a graphic standards manual but, instead, provided recommendations and guidelines for typefaces, paper stocks, and Pantone ink colors that were easy to follow. Previously, aside from the use of purple on newsletter and other communications, the choice of paper, type, and layout varied from designer to designer. Sayles also provided digital versions of the "big" and "little" animal illustrations so that they could be dropped into layouts, instead of the clip art that designers had previously been using.

"They do so many things internally—like fliers and newsletter—that it made sense for us to give them the resources to do so, but still maintain a consistent look," says Sheree Clark, cofounder, Sayles Graphic Design.

ABOVE: This pocket folder was printed with only one color one each side, which freed up some of the budget for an unusual diecut.

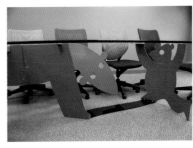

LEFT: When BBBS moved into a suburban office building in 2002, they needed an identifying mark outside the building. "The addition of a sculptured metal sign is equally about identification and aesthetics through the artistic use of the now-familiar pairs of flowers, butterflies, and animals," says Sayles.

LEFT: Two metal bears support a glass tabletop in the conference room. The powder-coated figures are constructed to fit securely together.

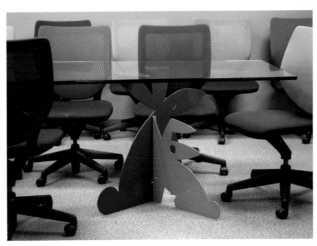

ABOVE: Textured and coated metal in multiple colors bring the seal to life in an illuminated "aquarium" in the BBBS lobby.

ABOVE: The organization's new interior décor includes furniture designed by Sayles that carries through the identity's big and little theme. Here, a pair of sculpted snails and a custom-cut piece of glass make up an eye-catching coffee table that sits in the complex's lobby.

ABOVE: There's no missing the pair of rabbits hiding beneath this meeting table. Each office in the BBBS facility sports a different pair of brightly painted pairs of animals as a "vivid reminder of the mission of BBBS: role modeling, support, guidance, and unconditional friendship," says Sayles.

What Works

The new identity has boosted the visibility of Big Brothers Big Sisters in the community to new heights. The move to the new location was the perfect opportunity to make such a drastic change. The organization had the chance to really promote itself and ask for financial contributions and volunteers without hesitation. The organization was able to move into its new facility without dragging along some tired, dated identity; instead, it was proud of its new, energized appearance both in its surroundings and its communications material.

Kibu Branding System:
Dear Abby for Teen Girls

DESIGN FIRM:
Morla Design

ART DIRECTOR:
Jennifer Morla

DESIGNERS:
Jennifer Morla,
Hizam Haron

CLIENT:
Kibu

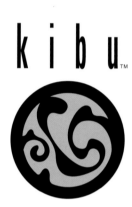

ABOVE: Kibu.com's previous identity had the Kibu name lock up on the vertical, making it difficult to read and giving greater weight to the logo than to the type. "It is imperative, that if a company's first connection with the consumer is online, the company or product name must be legible," says Jennifer Morla, Morla Design.

LEFT: The new identity retains the original circular motif but uses an updated color palette that works well online, in print, and in brick-and-mortar environments. It uses a proprietary Kibu font that works well in a variety of sizes. In addition, a secondary font was specified that can easily adapt to tag lines.

The Process

Kibu.com is a Web site for girls ages thirteen to eighteen, providing interaction with and advice from professionals in areas such as sports, money, beauty, school survival, movies, relationships, and health. "Kibu is a place, a community, a resource, an experience, a friend, and a lot of fun," says Jennifer Morla of Morla Design. However, as with most dot-com start-ups, Kibu created its original branding on an ad hoc basis. Its name, Kibu, was invented, "which can be memorable, but works better in well-established categories," adds Morla. That is why she told Kibu that its name does not mirror the Kibu experience, which is the advice teenage girls receive from the Kibu professional team, called the 'personalities.'

With that said, Morla Design was retained to identify brand objectives, develop naming, create a new identity, and design every consumer and trade touchpoint. This included designing an age-appropriate Web environment that enhanced brand recognition. The team was also given the job of creating packaging, retail environments, and a monthly newsstand magazine—all in a five-week period.

RIGHT: The redesigned
identity uses a custom,
proprietary font created
by Morla Design along with
Univers and Trixie Plain.

a b c d e f g h i j k l m n o p q r s t u v w x y z
Kibu Univers

a b c d e f g h i j k l m n o p q r s t u v w x y z
Univers 45 Light

a b c d e f g h i j k l m n o p q r s t u v w x y z
Univers 55 Roman

a b c d e f g h i j k l m n o p q r s t u v w x y z
Univers 65 Bold

a b c d e f g h i j k l m n o p q r s t u v w x y z
Univers Black

a b c d e f g h i j k l m n o p q r s t u v w x y z
Trixie Plain

021C / 021U

877C / 877U

659C / 659U

382C / 382U

365C / 365U

635C / 635U

115C / 115U

They tackled the identity first. "Both the Kibu name and the identity have Asian overtones, which confuse consumer comprehension of the Kibu deliverables," Morla says. "Furthermore, the previous identity had the Kibu name lock up on the vertical, making it difficult to read and giving greater weight to the logo than to the type. It is imperative, especially if a company's first connection with the consumer is online, that the company or product name must be legible."

Since Kibu had already built some brand recognition in the marketplace, designers chose to retain the identity's circular motif. The new system accommodates additional modifiers, tag lines, and adapts easily to brand extensions. They updated the color palette to work well in online, print, and brick-and-mortar environments. The colors, as well as the custom Kibu patterns, are hip, bright, and age appropriate for teen girls. "The new Kibu identity system isn't one sole element but a vocabulary of elements that can mix and match in numerous, innovative ways," says Morla.

ABOVE: The color palette
uses a variety of colors
for a light, yet trend-
setting, design that is
in distinct opposition to
the previous identity's
color palette, which was
considerably darker.

LEFT: The revised identity
allows for various subbrands
as well as numerous pat-
terns for added variety.

kibu

With the logo agreed upon, designers started work on the
stationery system. Once again, they didn't feel the current
system expressed the Kibu experience. Morla believes that
business communications can, and should, go beyond putting
a logo onto each piece of correspondence. "The innovation
and brand objectives that a company wants to express to the
media, investors, and business alliances should be apparent
in all business and consumer communications. The receipt of
a business card or press kit folder is often the first, and most
important, impression of a com-pany," she says. "The new
Kibu stationery system is an amalgam of contemporary style,
photography, and unexpected surprises. The stationery intro-
duced the personalities of the content of Kibu as well as an
integral part of the Kibu identity. Interest is achieved through
a play of scale contrast, black-and-white photography, multi-
plicity of imagery, and asymmetrical identity designators."

BELOW: Designers repackaged
Kibu's original promotional
items using innovative,
contemporary materials
that struck a chord with
the target market.

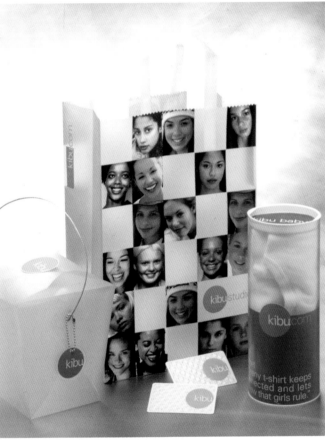

LEFT: Designers created a
shopping bag with images
that reinforce the visual
vocabulary established by
using a collage of snapshot
portraits of the typical Kibu
teen combined with the
KibuStudio identifier and
site address on a recycled
translucent polypropylene
bag. "When a girl who is
unfamiliar with Kibu sees
the bag, we want her to
think 'Hey, there's some-
thing there that is relevant
to me and girls my age,'"
says Morla.

The KibuCard is not a credit
card, per se, but more of
a club card. It "does not
resemble her parents' credit
cards and is uniquely Kibu.
It will live in the Kibu girl's
wallet. She will carry it with
her and show it off to her
friends," Morla explains.

When it came to promotional items, designers praised
Kibu for its research in identifying items that teenage
girls would appreciate, including incense, tea bags,
and lip gloss, all of which "tap into the Kibu gestalt by
providing giveaways that are out of the ordinary and
resonate uniqueness," says Morla. "What the items did
not do very well is establish the primary reason for
distributing the items—enhancing name recognition
and getting girls to visit Kibu."

Designers decided to use the same promotional items but asked themselves dozens
of questions about how they should be presented: Does the gift item need to be
boxed? What will girls reuse, thereby keeping the Kibu name top of mind? What
shapes and materials are appropriate for which items? What packaging will transi-
tion smoothly into merchandising system in a brick-and-mortar environment?
"Results showed that the packaging should be fun, reusable, or recyclable, have
merchandising possibilities, infer the dialog that symbolizes the faces, and highlight
the Kibu name," says Morla. To that end, designers repackaged the items using
innovative, contemporary materials that struck a chord with the target market.

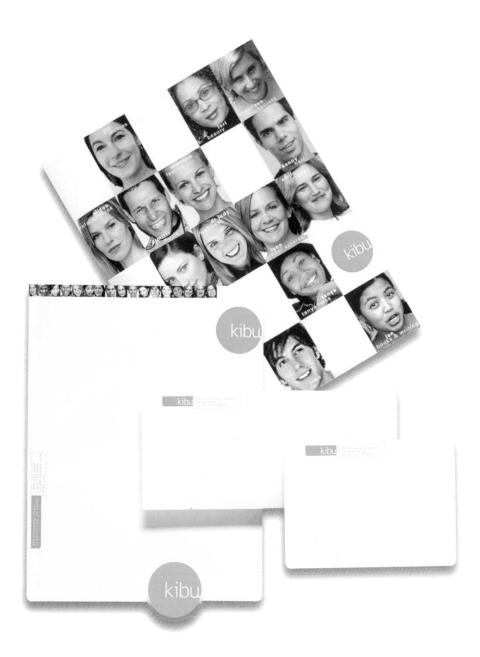

Next, designers tackled the core of the identity system, Kibu's Web site, which was technically
innovative, with plenty of smart content, but lacked a vocabulary that appealed to its target
teen. Morla's redesign of the site focuses on the uniqueness of the expert personalities,
reinforces the Kibu name recognition, and provides easy access to key pages. "The site is
less confusing, has more of an age-appropriate style, is more fun, and is easier to maintain.
Interestingly, all competitor sites, including Kibu's previous site, are dark and dense. The new
Kibu.com site is fun and smart," says Morla.

What Works

The before and afters of Kibu's identity are dramatic, particularly its Web site, at the heart
of the branding. The new identity is revitalized and extremely well suited to its young, yet
sophisticated and discriminating, teen market. This redesign proves that one size doesn't fit
all. A Web site geared to teenage girls must be designed by those who can get into a teen's
head, or it will never be successful in appealing to its audience or gaining market loyalty.

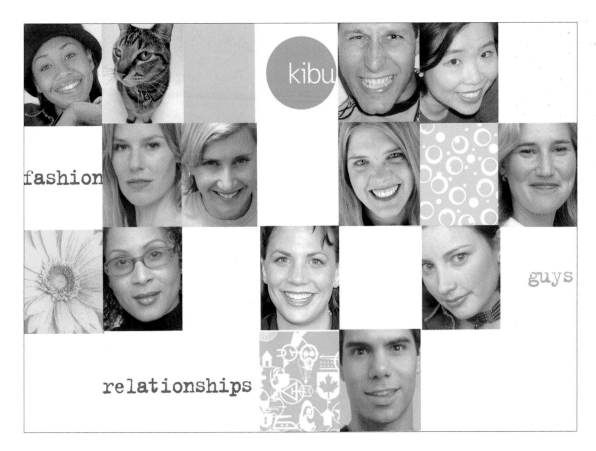

THIS PAGE: Morla redesigned Kibu.com to focus on the uniqueness of the expert personalities, to reinforce the Kibu name, and to provide easy access to key pages. It stands in stark contrast to the original site, which was dark and dense compared to the new site, which is colorful and light—with plenty of negative space.

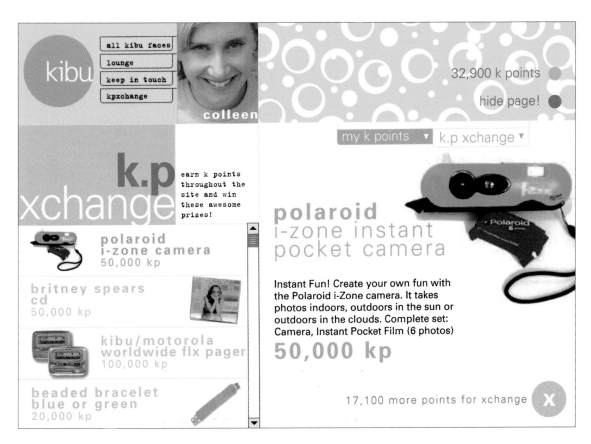

Galáctea 7:
Space-Age Graphics, Superhero Fun

DESIGN FIRM:
TD2, S.C. Identity and
Strategic Design Consultants

ART DIRECTORS:
Rafael Trevino Monteagudo,
Rafael Rodrigo Cordova Ortiz

DESIGNERS:
Rafael Trevino Monteagudo,
Rafael Rodrigo Cordova Ortiz,
Erica Bravo, Hernandez,
Edgar Medina Graciano,
Brenda Camacho Saenz,
Alejandra Urbina Nunez

ILLUSTRATORS:
Adalberto Arenas Castillo,
Sergio Enriquez Davila

CLIENT:
Helados Nestlé México

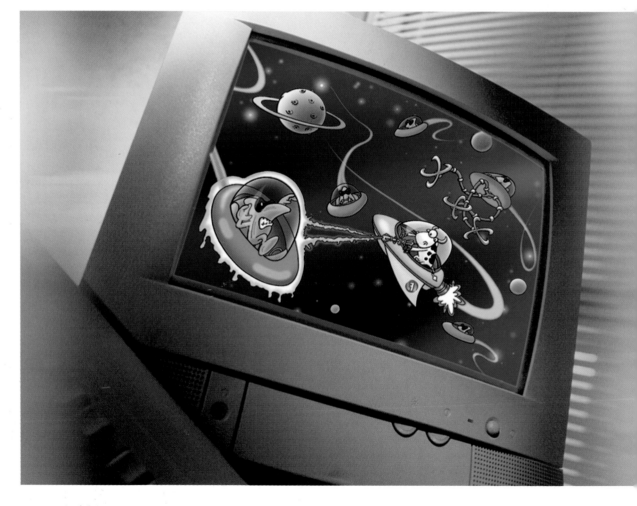

ABOVE: **Designers didn't
miss any opportunity to
bring these characters into
kids' daily lives—including
creating a screen saver that
keeps the Galáctea 7 brand
front and center.**

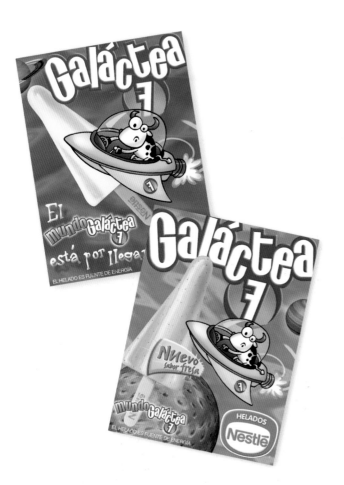

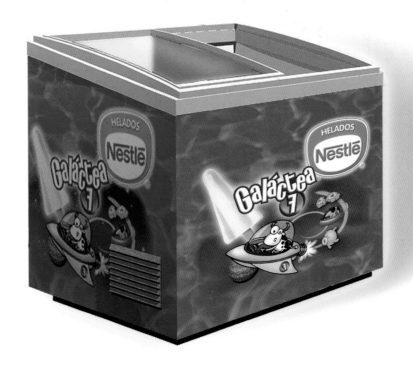

BELOW: Color is abundant on all the promotional materials to catch kids' eyes including the point-of-purchase displays, price board, and refrigerator display.

The Process

When Helados Nestlé México retained TD2, S.C. Identity and Strategic Design Consultants to launch its newest ice cream product targeted to eight-to-twelve-year-old kids, three primary objectives were clear. The identity had to innovative, relevant to the preteen market, and, most important, fun.

The dessert was already a known brand—La Lechera—being marketed to adults in a promotion that talked to its older market. This time, the product was being aimed at kids, so Helados Nestlé needed a new marketing approach.

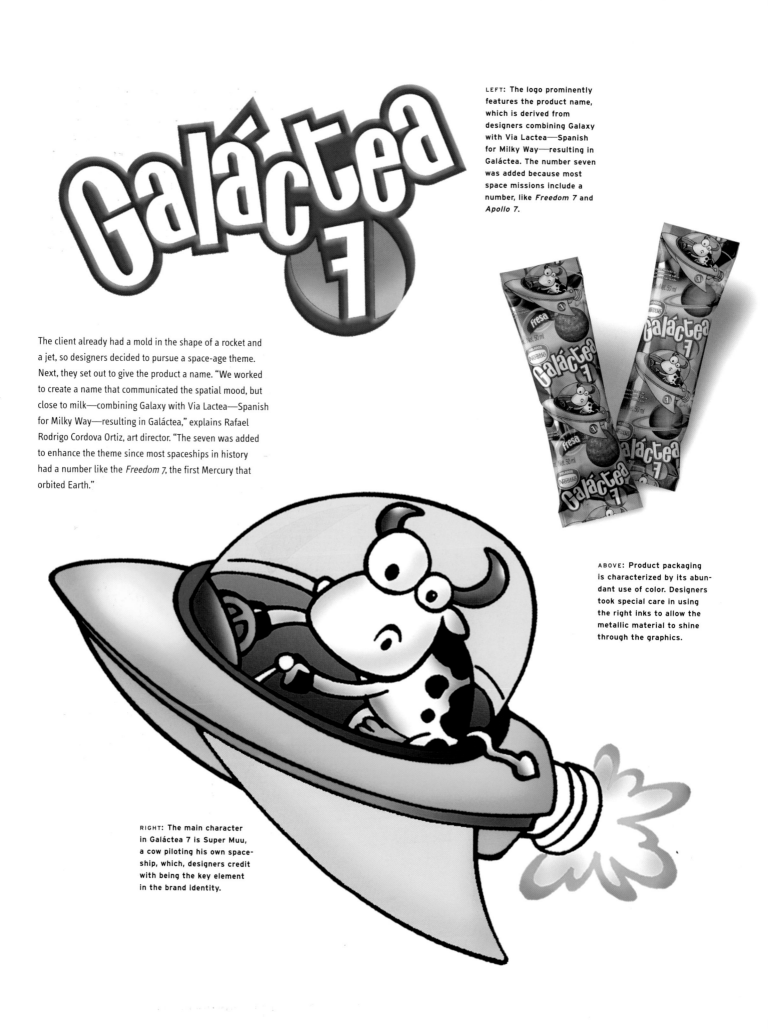

Galáctea 7

LEFT: The logo prominently features the product name, which is derived from designers combining Galaxy with Via Lactea—Spanish for Milky Way—resulting in Galáctea. The number seven was added because most space missions include a number, like *Freedom 7* and *Apollo 7*.

The client already had a mold in the shape of a rocket and a jet, so designers decided to pursue a space-age theme. Next, they set out to give the product a name. "We worked to create a name that communicated the spatial mood, but close to milk—combining Galaxy with Via Lactea—Spanish for Milky Way—resulting in Galáctea," explains Rafael Rodrigo Cordova Ortiz, art director. "The seven was added to enhance the theme since most spaceships in history had a number like the *Freedom 7*, the first Mercury that orbited Earth."

ABOVE: Product packaging is characterized by its abundant use of color. Designers took special care in using the right inks to allow the metallic material to shine through the graphics.

RIGHT: The main character in Galáctea 7 is Super Muu, a cow piloting his own spaceship, which, designers credit with being the key element in the brand identity.

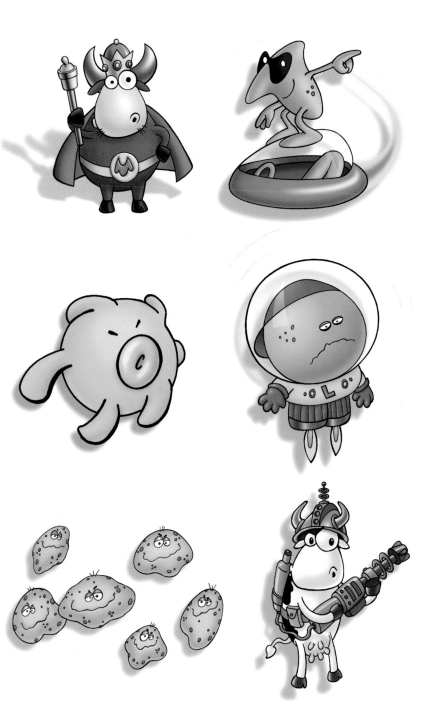

Adding personality and kid appeal to the spaceship is a superhero in the form of a cow—Super Muu, which became the single most important element of the branding, according to designers. "Through the use of humor and a very distinctive use of illustration, we came up with a very successful character," adds Ortiz. Designers went on to develop a family of characters with whimsical names— ReyMuu, Astroratero, Comeleche, LaloLelo, Virulelas, and Vaca Solado—who tell the story of Galáctea 7. Kids wanting to learn more about these characters can read up on their adventures from collectible cards included in the packaging.

BELOW: Collectible cards, included with the product, tell the individual stories of Galáctea 7's cast of characters.

ABOVE: The main character, Super Muu, is not alone in space. He has plenty of friends including ReyMuu, Astroratero, Comeleche, LaloLelo, Virulelas, and Vaca Solado—who tell the story of Galáctea 7.

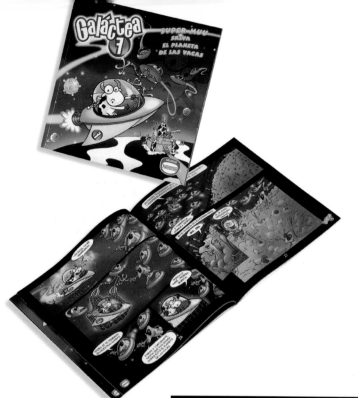

A cast of such colorful characters in space set the stage for action adventures, so designers created an accompanying comic book. Distinguishing all of the promotional elements is color—abundant color, sure to catch the eye of any kid wandering the refrigerated section of the grocery store. The vibrant use of color was no accident but part of the strategic design plan. "To achieve packaging with plenty of impact, we were very careful about using inks with or without a white base to allow the metallic material to live through the graphics," says Ortiz.

Delineating the do's and don'ts of the identity system is an equally colorful brand book. No staid standards manual will do for this product; its manual is as colorful as the packaging.

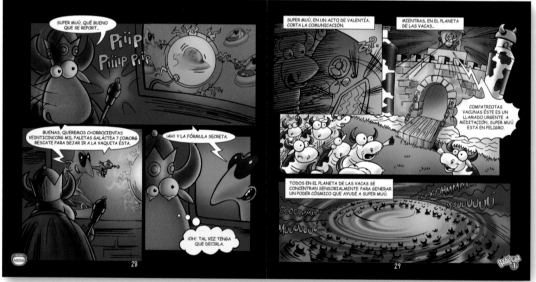

THIS PAGE: A comic book brings the cast of characters to life within an action adventure in space.

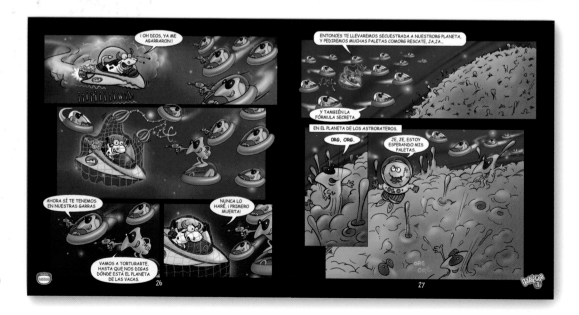

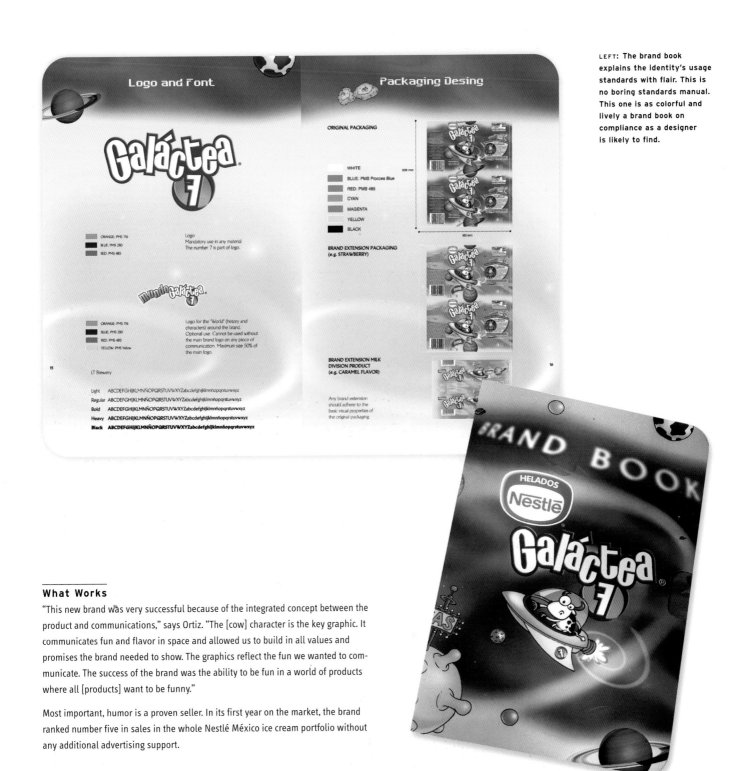

LEFT: The brand book explains the identity's usage standards with flair. This is no boring standards manual. This one is as colorful and lively a brand book on compliance as a designer is likely to find.

What Works

"This new brand was very successful because of the integrated concept between the product and communications," says Ortiz. "The [cow] character is the key graphic. It communicates fun and flavor in space and allowed us to build in all values and promises the brand needed to show. The graphics reflect the fun we wanted to communicate. The success of the brand was the ability to be fun in a world of products where all [products] want to be funny."

Most important, humor is a proven seller. In its first year on the market, the brand ranked number five in sales in the whole Nestlé México ice cream portfolio without any additional advertising support.

A Look Back

HASBRO: Achieving the Logo They Were Always Meant to Have

DESIGN FIRM:
Salisbury
Communications, L.L.C.

CLIENT:
Hasbro

THIS PAGE: **The old logo, above, became a true reflection of the company with it's new logo's smile, right.**

Hasbro, maker of such timeless toys as G.I. Joe, Candy Land, and Monopoly, was looking dated and needed a lift—an image that spoke to kids and to the joy they feel when they play with a new toy.

Salisbury Communications, L.L.C. came on board to help. Designers studied the original logo and decided it was way too serious for a fun-loving toy company.

Finally!
The logo we were always meant to have.

After all, when it comes to fun,
we've got the monopoly...

...and G.I Joe, Mr. Potato Head, Candy Land,
Star Wars, Tonka Trucks and Nerf. And we
don't really care what our lawyers say. The world
is welcome to share it.

Many toy companies
consider changing logos.

But only one had
the Nerf.

And the Monopoly,
the Mr. Potato Head,
the Star Wars Action Figures,
the Tonka Trucks,
the G.I Joes,
Milton Bradley.
Playschool...

The Hasbro smile. Hasbro From our face to yours.

They kept the color palette, but enlivened the mark with
a lighter, more carefree typeface coupled with a smile
"to brand them before McDonald's did with the same
rationale as the hamburger used later," says Mike
Salisbury. "A smile is the most universal facial expression
in the world. Hasbro makes toys. Toys make people smile."

Not everyone involved with the toy industry is as receptive
to change as kids are to trying a new toy. To convince
the board of the need for a brand mark that had impact
—that was a memorable visual for the company—we
created ads to announce the new logo—for *The Wall
Street Journal*, because that is where Hasbro, with its
multitude of brands, needed identifying—with investors,"
says Salisbury.

Travel and Dining

Marketing materials designed for the travel industry and luxury products, pose entirely different challenges from graphic designer than work for business-to-business, retail, or entertainment clients.

In many cases, particularly with the travel industry, winning over one customer isn't enough to guarantee repeat business. You must win over brand new customers every day. It's like making cold calls on a regular basis. After all, while hotels have regular customers, the majority of guests are first timers. This is particularly true with airport venues, like d_parture Spa. It has a transient clientele so it must work harder to supplement the chances that travelers will have enough time to visit their location by giving them a reason to stop and make time.

Likewise, there are dozens and dozens of hotels a traveler can choose from when visiting a city. Why would he or she stay at one over another? When walking down aisles and aisles of wines, what makes one bottle stand out? And, what would make someone make a special stop at a bakery to pick up bread, when they can just as easily do it at a one-stop grocery store?

In this chapter, we're really talking about how designers have found ways to make consumers take the time to buy their client's product or service. These are luxury products and glamorous destinations that require an investment in time, appreciation for the finer things in life, and, above all, disposable income.

Designing graphics that motivate discriminating consumers to pause from their hectic lives and enjoy life, take time to rest and relax is no easy feat. After all, more likely than not, this market earned its disposable income through hard work. They also like to play hard and there are plenty of ways they can spend their time and their money. Giving them the reasons that resonate with them to spend it with your client is the secret to success.

Folio: Illusions about Winemaking

DESIGN FIRM:
HGV

ART DIRECTOR:
Pierre Vermeir

DESIGNERS:
Pierre Vermeir,
Martin Brown,
Damian Nowell

CLIENT:
Folio

LEFT: Designers developed the name and tagline to represent the merger of two wine merchants: Folio: A new world of wines. The logo is characterized by an artistic treatment of the letter *F*, which is formed by a wine bottle in midpour. The use of gold in the *F* mark represents the quality of Folio wines and the expertise for which they are known. The tagline supports the client's move into the New World wine market.

The Process

When two wine merchants merged into one company, the Beerseller Limited retained HGV to give the new company a name and a face—specifically, the company needed a visual identity and tagline that would convey the quality and expertise offered by the newly-formed company.

"The two merchants had outdated identities and promotional materials, in particular, they were very down-market—at odds with the high-quality wine lists," remembers Pierre Vermeir, art director at HGV. "The new identity had to represent high-quality wines and also drive increased sales of New World wines—a growing market across the United Kingdom. The new brand name and visual identity had to be contemporary without being so radical that it offended existing customers.

"It was also important that the sales force feel comfortable with the new identity, as it represented a restructuring for both companies, relocation for some, and a new sales drive into the New World wine market."

Designers set to work on the name and, after much research, suggested Folio. Then, they added the tagline, "A new world of wines," which reinforced the new sales initiative and would help support future sales of wine brands from Chile.

Designers set the new name in a sans serif, linear typeface and ran it vertically alongside a capital letter *F*, which is artistically formed by a wine bottle in mid-pour. The use of gold in the *F* mark represents the quality of Folio wines and the expertise for which they are known. The tag line supports the client's move into the New World wine market.

Gold and black are the hues used predominantly in this identity, and are integral to the visual illusion designers created using a wine bottle pouring forth its contents of high-quality wine, communicated by its golden color. This visual illusion is best exemplified by a pen created as a promotional item. When the black pen is turned upside down, the golden color acts as the bottle's cork; when uprighted, the golden color fills the contents of the bottle.

ABOVE: Designers created a unique promotional item in a pen that, when upside down, looks as if the wine bottle on its side is empty. When up righted, the wine bottle is full.

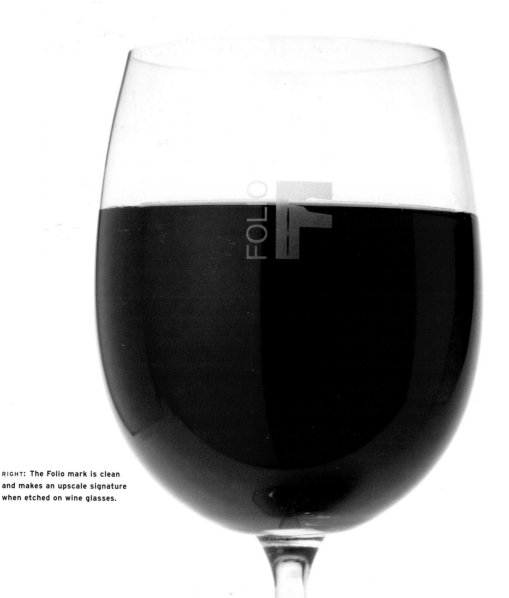

RIGHT: The Folio mark is clean and makes an upscale signature when etched on wine glasses.

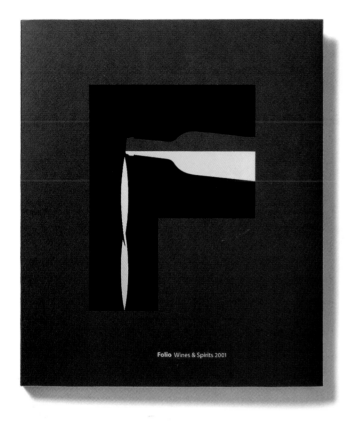

Folio Wines & Spirits 2001

THIS PAGE: Designers suggested Folio invest in one comprehensive catalog, which is spiralbound and features black-and-white photography as well as color photos of winegrowing regions around the world.

The golden "liquid" is the most important element of the logo, according to designers because "it communicates that Folio wines are nectars," says Vermeir.

With the logo in place, HGV recommended that the client invest in one outstanding wine catalog as the main vehicle for communicating the new brand values. "Vineyards in Australia and Chile, for example, were given equal visual weight with vineyards of France and Italy, which had previously been given pride of place," Vermeir explains.

THIS PAGE: The gold used in the predominantly two-color identity is the "nectar" that flows from a wine bottle on this interactive folder. In order to "open" the folder, recipients extract the golden insert from the piece, which gives the illusion that they are emptying the bottle of its contents. When the golden insert is fully withdrawn from the sleeve, the wine bottle is empty.

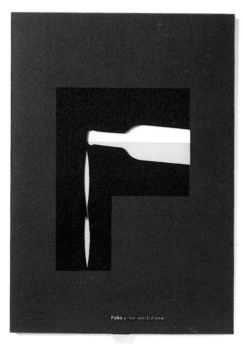

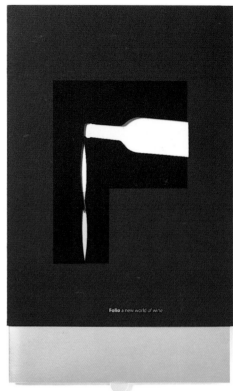

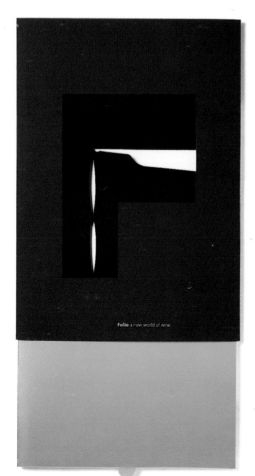

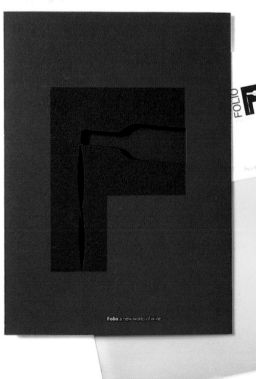

BELOW: The Folio Direct
catalog leads readers inside
by showing only a portion of
a corkscrew on its cover.

The "nectar" is once again a predominant theme in the company's folder that houses promotional material. The cover of the folder is diecut in the name of the bottle in midpour where the gold shines through the diecut as the wine in the bottle. In order to "open" the folder, recipients extract the golden insert from the piece, which gives the illusion that they are emptying the bottle of its contents. When the golden insert is fully withdrawn from the sleeve, the wine bottle is empty.

"The Folio name and identity has proved an effective tool for generating a new and authoritative image for the wine and spirits division," says Vermeir. "It offers both the credibility to win the [business] of the prestigious De Vere hotel chain—twenty hotels, eighteen villages, and eight Greens health clubs—and the flexibility and modernity to appeal to the pubs, bars, and restaurants that are key to the company's strategy. For example, Folio is now sole supplier of wine and spirits to the two hundred pubs in the Eldridge Pope estate and the 107 tenanted and managed pubs of Henley-based brewer Brakspear. Folio's sales in the key pub, bar, and restaurant sectors have grown by 32 percent.

"An important part of the strategy is to build business in line with the latest consumer drinking trends as reflected in sales in the off trade. Folio embraces the trends of the 'new world of wine,' and sales of New World wines, for example, grew by 36 percent last year."

In a year when wine sales in the on-trade grew 12 percent in value, Folio increased sales of wine by 30 percent in the ten months prior to February 2002, compared with the combined sales of Eldridge Pope Vine Wines and Saccone and Speed for the same period the previous year.

What Works

"The Folio name, logo, and house style have been well received," says Vermeir. "In a recent survey of employees and trade customers, 94 percent of respondents thought that the new catalog was good or very good, with ninety-seven percent agreeing that the presentation style 'is modern and up-to-date' and 76 percent considered it to be better than other wholesaler wine and spirits catalogs."

ABOVE: A variety of promotional items were produced to launch the brand identity, including paper blocks that are printed with photographs, which also appear in the company catalog.

d_parture spa:
A D_parture from the Norm

DESIGN FIRM:
Zinzell Art Direction
& Graphic Design

PHOTOGRAPHER:
Timothy Darwish

CLIENT:
d_parture spa

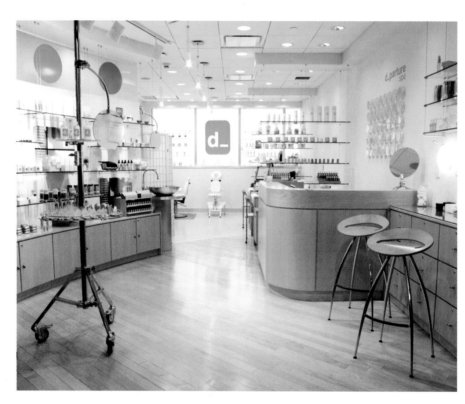

LEFT: The interior palette features lots of white, natural ash fixtures, plenty of glass, accented with bright pops of orange. A soothing scent also permeates the salon.

d_parture
spa

ABOVE: Out with the name Travel Tips Salon and in with the new—d_parture spa, which is modern, different, and speaks to the airport traveler.

The Process

Travel Tips Salon, a spa opening in Newark's International Airport, made one big mistake prior to its opening; it hired an architect to develop the store design before retaining Zinzell Art Direction & Graphic Design to create its branding. Consequently, when Zinzell took on the job, the client had a very non sexy name and its image was already tired and worn, with a dark color palette more in tune with the 1980s than with the twenty-first century.

The salon needed an immediate makeover. It had to be sexy and alluring if it was to succeed selling pedicures, manicures, massages, haircuts, make-up services, and travel-related body care products to a transient clientele. "When they came to us, they realized that they had missed the important step of first figuring out the identity platform," remembers Don Zinzell. "We did fast-track market research and realized that there was an opportunity to become a more sophisticated spalike shop. We did additional target customer research and, with all this information, created the current brand identity. Understanding the market and your customers is the only way to create a brand that has relevance and a successful, long life.

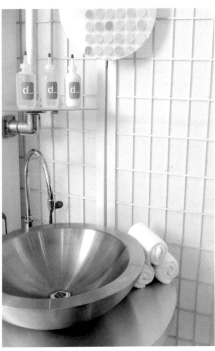

BELOW: The exterior of the spa is not unlike what you'd find in an upscale neighborhood. The windows are large, for a light, airy feel.

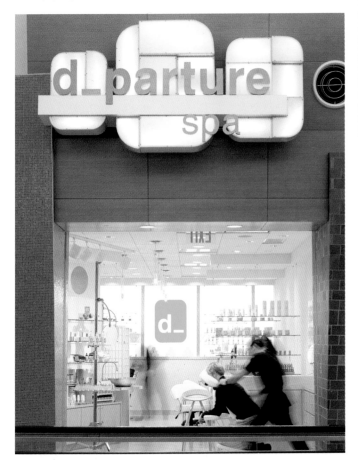

BELOW: The interior signage looks more like abstract art than a store sign.

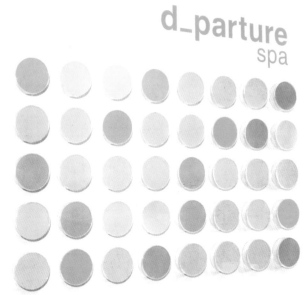

LEFT: The identity created for d_parture spa hinges on a logo that works as a stand-alone icon on packaging and stickers to one part of the larger system.

"The old identity didn't work because of its name, style, and attitude were too dated and the client didn't realize the potential for creating a market niche. As a typical manicure/barbershop, blending in with the current airport shop would have made this concept nothing more than 'just another dull airport shop.'"

Zinzell set out to create a new benchmark in the retail travel industry and pushed the envelope to exceed the expectations consumers have of an airport store by developing a brand that was fun, could be rolled out worldwide, and would be instantly recognized through strong imagery.

The team started by changing the spa's name to something more upscale, unique, yet in keeping with the airport travel theme vernacular—d_parture spa. Next, they created a strong, easy-to-recognize graphic culture.

OPPOSITE: The secondary elements in the visual identity are in keeping with the airport vernacular, so they are easily recognizable to travelers with little time and, more important, to those who are unfamiliar with the spa and its services.

THIS PAGE: The spa sells a variety of products—most in travel sizes. The packaging ranges from the full product name to products featuring just the spa's stand-alone icon graphic of a lower case initial *d*.

"The identity speaks to a broad range of customers," says Zinzell. "It's universal. It's positive. It's inclusive, not exclusive yet unique. The graphics complement airport signage and seem to speak the traveler's language, yet they are modern and fresh, and more like what you'd find in an upscale neighborhood spa than in an airport where all stores are remarkably canned and generic, and not at all inviting and welcoming.

"There is no single most important element to the design other than creating a complete program and make everything look like it's related," explains Zinzell, who says he tried to create an emotional link between the brand and the customer—connecting on a human and lifestyle level rather than on a corporate level.

"If you design a great logo for a store, but the store design looks drab, looks like its not part of the same soul, you're not going to be successful. Everyone involved in realizing the brand, the graphic designer, architect, interior designer, should speak a visual language relevant to the core identity," he says. "Everything the customer sees or touches needs to feel like it came from the same thought. It's the only way to make a strong impression, be convincing and make that connection with the customer."

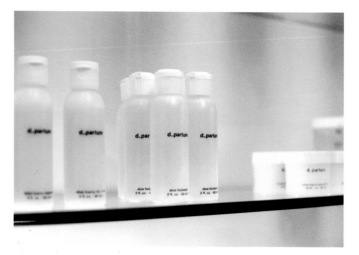

RIGHT: d_parture spa's
Web site promotes the
many products available
at the spa.

BELOW: A countertop sign
introduces a flower theme
to the identity, in a bright
pink, completing the
primary orange palette.

RIGHT: A poster designed
for the spa promotes the
products the spa sells as
"flight gear" for travelers
who may have forgotten
to pack some necessities.

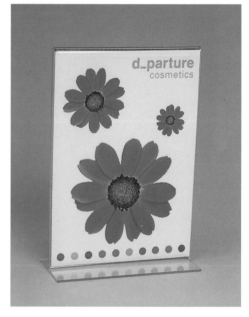

The d_parture spa makes the strong impression Zinzell speaks about. At the cornerstone of the identity is a strong logo that works as an independent, stand-alone icon or with other visuals. "There is a personality, an attitude with which you speak to the customer, verbally as well as graphically. It's also very important for a brand to be modular and evolve—to keep up with changing times. If you look dated, chances are that the customer will move onto the next best thing. Evolving doesn't mean that you have to change completely.

You take what you have and update it. It's like having an identity makeover. When the change is relevant to the brand's soul, it can only be positive," Zinzell says.

The total package—including everything from the logo and stationery to environmental signage, packaging, store design, and shopping bags, is one that appeals to the weary, detained traveler, the traveler, frustrated by cancelled flights, as well as the plan-ahead traveler, who would anticipate the extra time before a flight to include a visit to the spa in his or her travel plans. "We created a complete image that travelers, without a lot of time to spare, could recognize from a distance and could easily remember," Zinzell adds.

BELOW: The business card, gift certificate, and menu of services feature a pale blue and orange two-color palette that repeats the graphic theme.

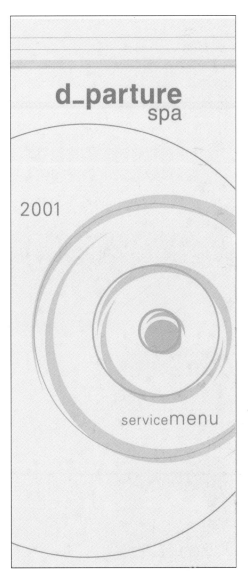

This certificate is redeemable for merchandise or services at **d_parture** spa. This certificate is not redeemable for cash. Not valid unless signed. **d_parture** spa will not be responsible if certificate is lost or stolen.

twenty-five dollars

customer signature

250105

Redeemable at **d_parture** spa > 973-242-3444 > www.departurespa.com

d_

LEFT: Shopping bags were designed with the circle artwork on a translucent stock.

What Works

What works? Everything. The store is so unlike anything else one would expect to find in an airport that its novelty alone created plenty of talk in the industry, where the spa has been recognized by its peers with several industry awards since its opening. The media were intrigued, too, and gave it plenty of exposure, effectively spreading the word.

According to Zinzell, d_parture spa is planning on opening locations worldwide. "This most likely would not have happened with the traditional hair salon concept. We developed a model for a new standard in the travel industry," says Zinzell.

"We delivered the unexpected. We created a brand that appealed to the target customer and their world. We didn't want to make it too sterile and spalike, but wanted a more inviting environment that customers would feel comfortable walking into."

Eliza Was Here:
An Identity That Leaves Its Mark

DESIGN FIRM:
Ping Pong Design

ART DIRECTOR:
Bert Rorije (Directions)

DESIGNER:
Ping Pong Design

PHOTOGRAPHER:
The Lomographic Society
(www.lomo.com)

CLIENT:
Eliza Was Here

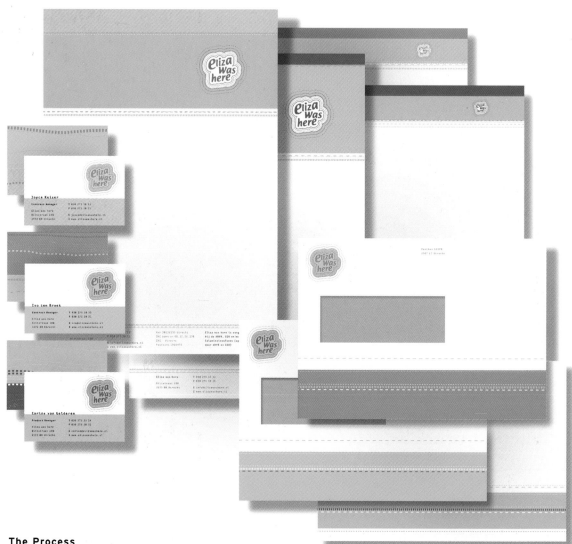

The Process

Think hard, now. When was the last time that travel was fun? Most people can't remember it ever being anything except a hassle, but clearly, Ping Pong Design and its client, Eliza Was Here, are working hard to change that perception.

Eliza Was Here, a new online travel agency, was in need of identity, so it tapped Ping Pong Design to help give the agency character—something that would distinguish it from the dozens and dozens of online travel agencies populating the Internet. The client wanted to project a personal touch in the

ABOVE: **Varying color bars are highlighted with dotted lines, dashed lines, and other linear elements giving the impression that anything goes on this letterhead package. The one consistent element is the Eliza Was Here mark that shows up unexpectedly.**

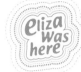

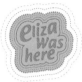

ABOVE: The Eliza Was Here icon uses various color palettes for a vibrant and colorful presentation. This same icon shows up as stickers or a stamp throughout the identity.

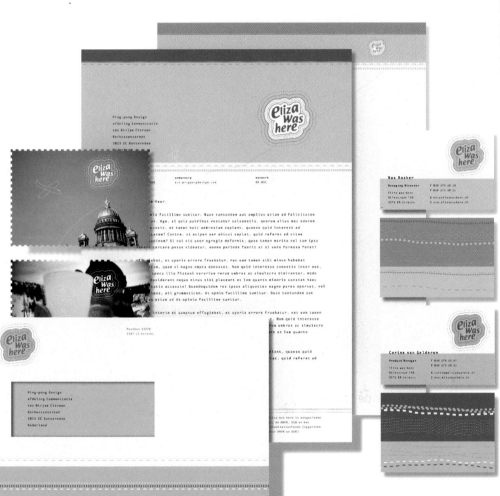

impersonal world of the Web; they wanted to be "a somebody rather than a corporate body," says Mirjam Citroen, Ping Pong Design.

Designers set to work creating a logo that works like a tag, label, or stamp. "Wherever she goes, Eliza makes a real impression and leaves her mark. The tone of voice is very personal. The agency behaves and interacts like a persona, an individual," says Citroen of the logo that was designed to work within an identity, but also as a stand-alone item, with a sticker being among its most common and perhaps, successful, applications.

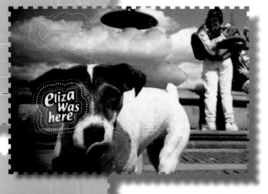

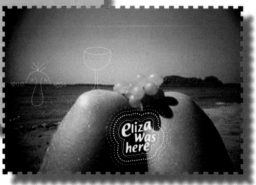

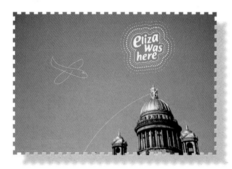

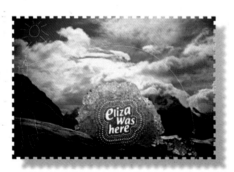

THIS PAGE: **Eliza is a whirlwind traveler, sending postcards from each destination she visits but not before she doodles across the front of them, placing her usual Eliza Was Here mark in a distinctive spot.**

More important, the logo is vivid, playful, and colorful, which designers say, exactly describes the organization. "Its explicit depiction of the central concept—fun—is the single most important element," says Citroen, which drives home the message that traveling is fun—a foreign concept to many travelers—yet, here, it is remarkably convincing.

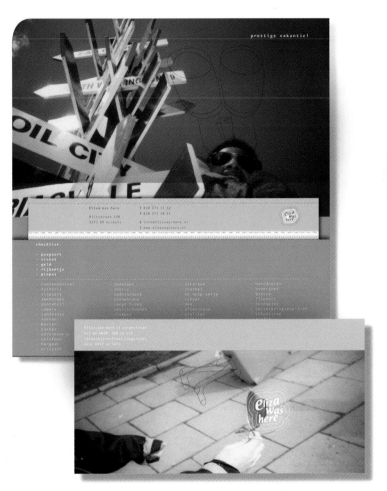

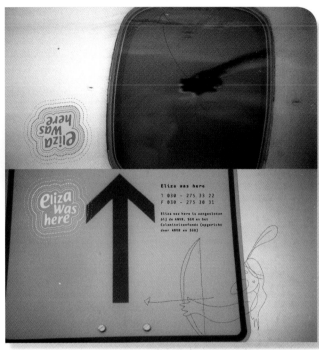

The graphics are fun, too. Nothing is formal or traditional. Instead, graphics are accented with all sorts of amusing and curious doodles and cartoonish line drawings. "The use of color and the diversity of visual material give the impression that Eliza vacations are personalized, one-of-a-kind, fun; there's nothing standard about them," Citroen adds.

By looking at this identity, one would find it hard to believe there is a standards manual, but while the logo takes on many different color palettes and it appears as though anything goes, there is a rhyme and reason to its execution. The letterhead system appears fun and offbeat, but when the individual pieces are presented as a collection, the entire package projects both a semblance of order and of whimsy.

With the logo and letterhead system in place, designers created a series of postcards as part of a direct mail campaign. The borders of the cards are diecut to look like the perforations on a stamp, and the front of the card features photos of different places around the world, all of which carry Eliza's distinctive—Eliza Was Here—mark.

Likewise, ticket wallets feature the same doodles and Eliza Was Here stamp along with a packing checklist, all of which accent the photography.

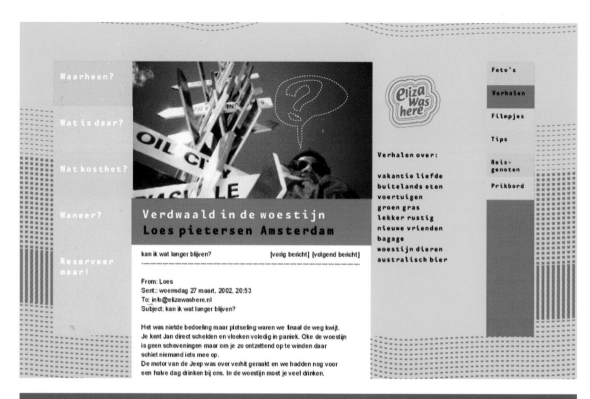

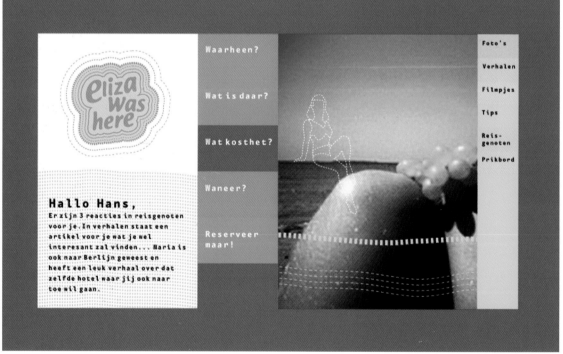

THIS PAGE AND OPPOSITE:
Designers created a Web site
that uses the same vibrant
color palette that is the hall-
mark of the print collateral
and, once again, the site is
personalized and features the
same doodles and cartoon-
like drawings on the travel
photographs and Eliza Was
Here icons.

Naturally, since the travel agency does its business online, the identity had to work to its best advantage on a Web site. To that end, designers created a site that uses the same vibrant color palette that is the hallmark of the print collateral. Once again, the site is personalized and features the same doodles and cartoonlike drawings on the travel photographs, and Eliza Was Here icons.

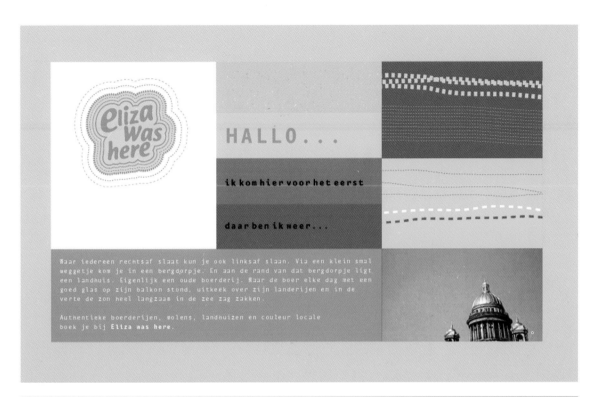

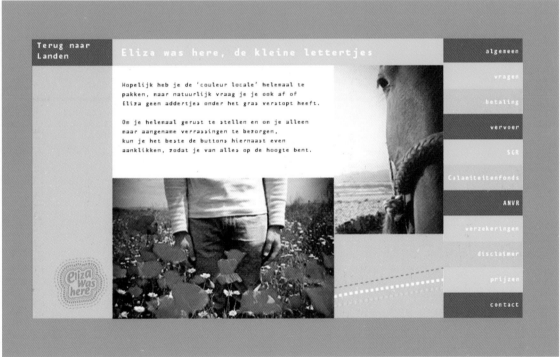

What Works

Undoubtedly, planning a vacation is a lot more fun than planning a business trip, but even so, this firm's identity makes it even more enjoyable. "The graphics appeal to young consumers looking to have some fun in the sun. The graphics themselves are a holiday," says Citroen.

"It's difficult, if not impossible, to quantifiably measure the effects of a new corporate identity," she adds. "However, Eliza has already begun to leave her mark. Eliza stickers were reportedly spotted in the ladies toilet at Athens airport!"

Hôtel St. Germain:
G is for Graphic Monograms

DESIGN FIRM:
Paprika Communications

ART DIRECTOR:
Louis Gagnon

DESIGNERS:
Louis Gagnon,
Francis Turgeon,
Annabelle Racine

PHOTOGRAPHER:
Michel Touchette

CLIENT:
Groupe Germain

The Process

What started as a simple identity project turned into a comprehensive branding
program when Paprika Communications was retained to develop the identity for
a new Montreal hotel. The hotel was part of a small chain of boutique hotels, but
since it was the first one called Le Germain, designers didn't have to conform to any
preexisting graphics standards in place for the two sister hotels. When Germain-
des-Prés Developments decided to convert a 1970s office tower in downtown
Montreal into the 150-suite Hôtel Le Germain, they needed that special something
—that intangible feeling of status and elegance that can be communicated by
a well-defined, creative, graphics-based branding program.

ABOVE: Designers opted for
a neutral color palette of
taupe and cream in keeping
with the renovation's archi-
tectural and interior design
details. Here, the logo and
its colors make a statement
when guests enter the hotel
and step onto its carpet.

HÔTEL LE GERMAIN

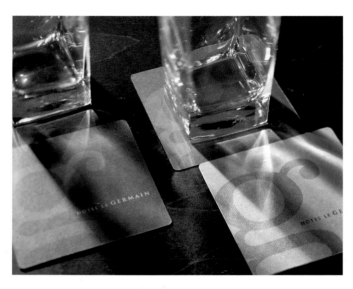

LEFT AND ABOVE: **Coasters feature the monogram logo, which uses the lowercase _g_ in Clarendon, a nineteenth-century typeface.**

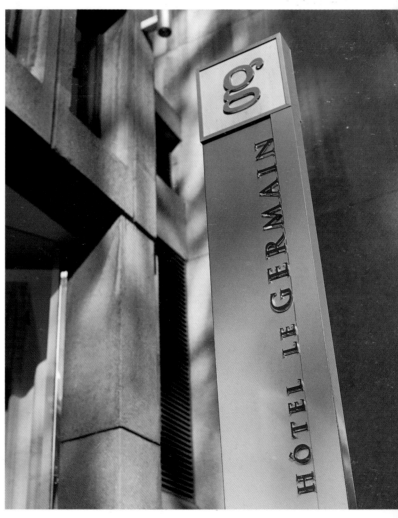

Paprika Communications was awarded the project of developing the new look and corporate identity while the building was being renovated. "The building wasn't particularly bad, but it didn't have all that much character," says Joanne Lefebvre, who cofounded Paprika in 1991 with Louis Gagnon and is now the president. "It was a rectangular structure with large windows and pure, sober lines. You could have given it any personality, really."

The owner wanted a "boutique hotel" that would appeal to sophisticated business customers but also attract upscale tourists; Hôtel Le Germain was to be the best of its kind in Montreal. "We had a very clear idea of what we wanted to accomplish," says Lefebvre. "It had to be considered as one of the best hotels in its category, not only in Montreal, but in North America—New York, Boston, and San Francisco. The most important thing about a boutique hotel is the fact that refinement is… everything. You have to select everything you offer your clients very carefully."

RIGHT: **The designers collaborated with the architects during the renovation to make sure that the graphics would complement the new building, which was being transformed from a non-descript office building to a boutique hotel.**

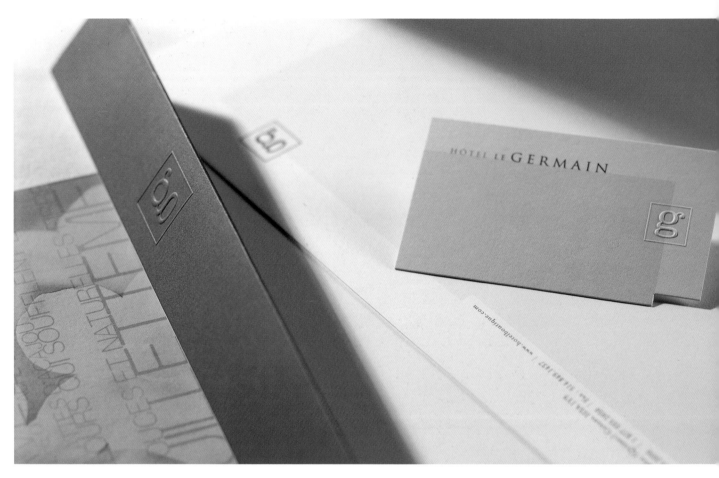

That was the reasoning behind designers choosing to use a monogram as the logo. "The *g* would be our quality signature," explains Lefebvre. "We would use it to communicate the fact that we had selected this product or this service to make sure your experience of staying at Le Germain would be the best it can be." Designers also liked the idea of a monogram because it meant they wouldn't have to spell out the full name. "That became increasingly important as the program grew to include more and more items." They set the lowercase *g* in Clarendon, a nineteenth-century typeface. "We wanted something pretty, but also timeless—a mixture of something hip with something very classical."

Designers worked on basic elements of the branding such as the letterhead system and collaborated with architects and interior designers to ensure that the new interior and exterior graphics complemented the work being done as part of the renovation. Designers went for a classical appearance, avoiding anything trendy, and chose a neutral color palette of taupe and cream that would work in tandem with the building's architecture and interiors.

"The creative line was 'hotel of the senses.' We wanted everything to be perfect," says Lefebvre.

Everything is very near perfect, too. The deceptively simple monogram can be seen everywhere. The client liked it so much that they asked designers to incorporate the logo throughout the hotel—effectively branding the building and all of its contents. It shows up where one might expect to see a monogram—embroidered on a hotel robe, as well as in unlikely places, such as on the porcelain faucet inserts in the guest bathrooms and on the carpets. Such attention to detail is abundant in this identity where no opportunity is overlooked to remind travelers of the brand. "It started out as a corporate identity but turned into a branding program," says Lefebvre.

RIGHT: Matchbooks are also high end, with the logo printed on the box tray that holds the matches, while the name of the hotel runs atop the sleeve. The ashtrays also sport the distinct *g* monogram.

RIGHT: Designers created the packaging for the body care products found in guest rooms and have just completed a promotional brochure that is linked to the hotel's Web site, which allows guests to buy about everything they saw in their room, from its sheets and pillows to its furniture and glasses.

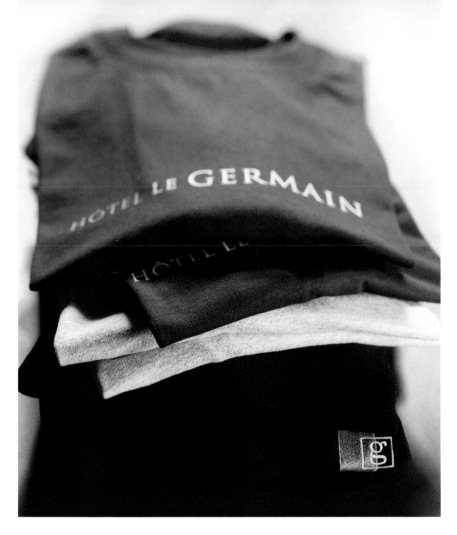

"We must say it was very successful," says Lefebvre. "Not only because of the branding program, of course. But it was the whole operation that turned out to be a very big success."

The project took about one year, but the relationship didn't end when the project did. Paprika Communications continues to create and develop new applications for the logo at the St. Germain. The work is getting plenty of attention, too. The media coverage has been phenomenal and, according to Lefebvre, specialized tourist guides have given the hotel very high marks. Christiane Germain, the president of the establishment, has made appearances on television shows and and has received numerous awards for her work by the tourist industry. The branding program and its components were recognized in major graphic design contests like Communication Arts, Applied Arts, Art Directors Club, Graphis, Grafika, Montreal Design Institute, and Creativity. Most important, the hotel and its ambiance attracted a lot of attention in Montreal and worldwide.

What Works

The logo works. The *g* has become such a strong logo in the tourist industry that the client decided to keep the brand for another new hotel in Toronto rather than risking developing something totally new.

El Globo:
Revamping a 120-Year-Old Bakery

DESIGN FIRM:
Burgeff Co.

ART DIRECTOR/
DESIGNER:
Patrick Burgeff

CLIENT:
El Globo

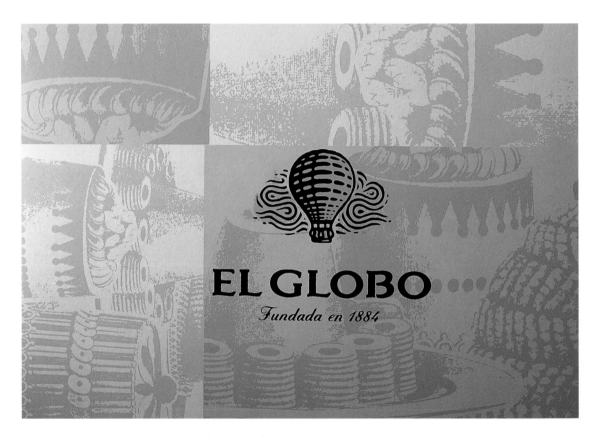

The Process

El Globo, a bakery with a history of doing business in Mexico that dates back to 1884, had changed its identity numerous times over the years. Its original logo in the late 1800s was a type treatment. Subsequent versions incorporated a hot air balloon to communicate El Globo's literal translation—globo—Spanish for balloon.

However, when Burgeff Co. was called in to give the bakery a new image, the logo it was using relied on a diamond pattern that had nothing to do with its rich heritage as a maker of delectable baked good for nearly 120 years or its history in the community. The diamonds were purely decorative without any meaning—either literal or abstract.

RIGHT: Old El Globo logos utilized a diamond motif that had no relation to the bakery's products or services.

"A balloon has been part of the identity since the beginning because El Globo means balloon in Spanish," explains Patrick Burgeff. "In the 1960s it was removed, and even though the word *globo* meant balloon, it was replaced with diamonds. The word and the symbol didn't match. [We needed] to create a new identity that expressed congruence with the symbol and communicated a high quality and tradition with a modern look."

Burgeff set to work creating the new logo and brought back the balloon that is so closely associated with the bakery. He added clouds and chose a typeface with rounded letterforms to mirror the roundness of the balloon and cloud shapes.

"Without clouds, the balloon looks static and has no context," he says. "Moreover, the clouds represent the freshly baked bread, meringues, and cake decorations. It's clean and it is formed with round shapes that are kind and harmonious, like pastry shapes, whipped cream, etc."

RIGHT: Burgeff Co. revised the logo to bring back the hot air balloon, which ties into the bakery's name: *globo,* Spanish for balloon. The balloon icon had been used previously but had long since been discarded. Burgeff brought back the image, updated it, gave it a two-color treatment, and then added a background for use as needed.

The logo adapts easily to exterior signage as well as delivery van and windows, which entices passersby to gaze upon the treats displayed in the showcase. The primary logo uses a warm color palette, evocative of the warm aromas that drift from the ovens, but Burgeff built in enough flexibility, so that it can appear in other colors when the application demands it.

For example, designers had to adapt the identity to scores of packaging applications and labels. Traditional packaging uses the traditional logo such as a belt for the traditional Pane di Toni cake, but at Christmastime, the belt is dressed up for the holidays using a seasonal palette. Packaging also had to be designed for numerous sized containers, boxes, and bags. The Boston Fruit Cake comes in both a tin and a box, while numerous paper bags were designed to hold everything from long baguettes to small and large loaves of kaiser bread.

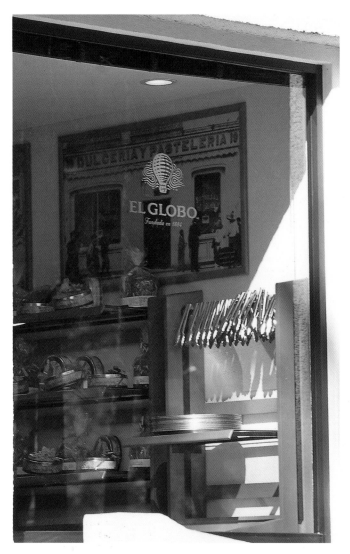

LEFT: **This window sign was created using a decal.**

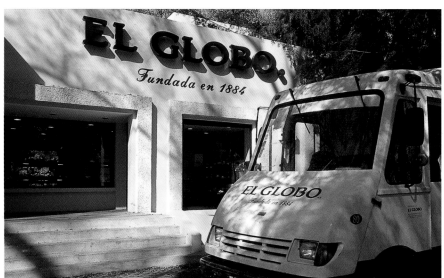

LEFT: **The typeface Burgeff chose for the identity works as well as the exterior signage as it does on small price labels. It is also immediately recognizable as delivery vans travel the roads around the bakery's one hundred locations.**

LEFT: To accommodate all the products, designers created two sizes of plastic bags and five sizes of paper bags to fit everything for large and small loaves of kaiser bread to French baguettes.

BELOW: Boston Fruit Cake comes in a tin or a box, so designers had to be ready with both designs.

HIGOS CONFITADOS

Cont. Net. 500 g

EL GLOBO
Fundada en 1884

frutas confitadas

de cremas

petit four

Cont. Net. 525 g

EL GLOBO
Fundada en 1884

surtido de tartas miniatura de crema

BOLLOS

CONT. NET. 175 g

EL GLOBO
Fundada en 1884

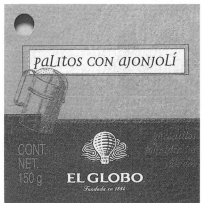

palitos con ajonjolí

CONT. NET. 150 g

EL GLOBO
Fundada en 1884

OREJITAS

hojaldre crujiente de mantequilla

Cont. Net. 295 g

EL GLOBO
Fundada en 1884

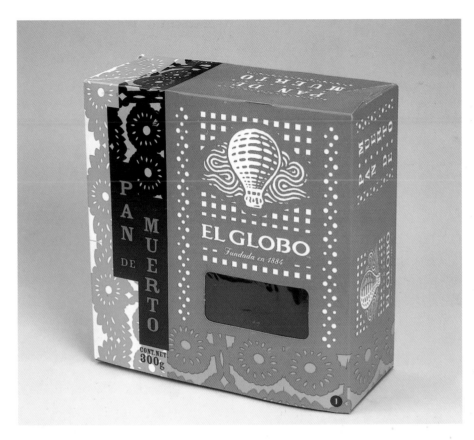

LEFT: Pan De Muerto is packaged in a special box that uses a bright pink and green palette accented with black.

BELOW: Special packaging was created as needed, which was the case during Christmastime when the traditional Pane di Toni belt was dressed up for the holidays.

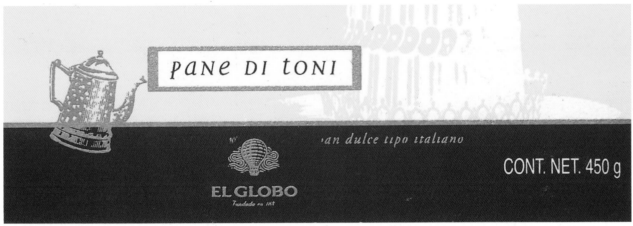

"People immediately recognize El Globo products," says Burgeff with pride. "The balloon figure is a harmonic concept in people's minds." It took a lot of research, but Burgeff says in the end, he was able to integrate the traditional look in a modern era so that the graphics would appeal to the target market.

What Works

The graceful forms and refined compositions work, according to Burgeff. "Within six months people became aware of the revamping. This identity represents almost one hundred shops in the country, and it is now the number one bakery in Mexico."

Wolf Blass:
Rejuvenating a Fine Wine

DESIGN FIRM:
CPd

ART DIRECTOR:
Chris Perks

DESIGNERS:
Chris Perks, Tony Charlton,
Damian Kelly

CLIENT:
Wolf Blass

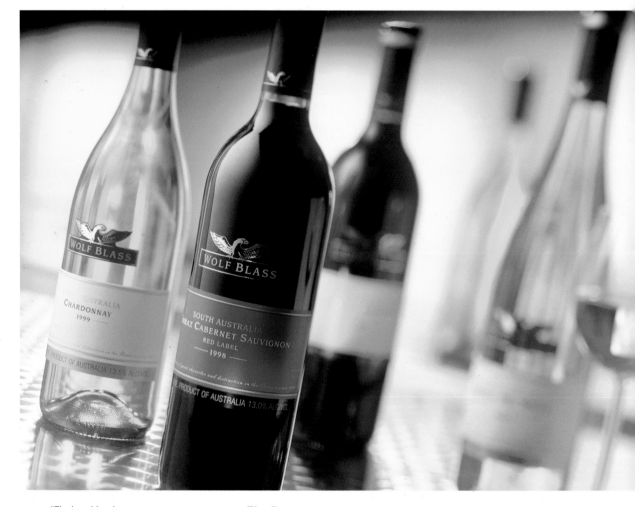

ABOVE: "The brand has been contemporized but it is still identifiably Wolf Blass—the same brand that consumers know," says Chris Perks, CPd. "Labels are simpler and easier to read. There is strong color impact."

The Process

Wolf Blass was first introduced to the wine market—both in Australia and overseas—in the late 1960s with considerable success. But in time, its makers acknowledged that it was not performing up to its potential. Sales were not as strong as they once were or should be given the quality of the wine and the market conditions. Recall was strong among consumers but sales figures don't lie, so manufacturers decided to relaunch the brand.

CPd was hired to create a new identity and make Wolf Blass "new and more appealing in Australia where it had a strong heritage and to increase its performance overseas as a flagship export brand," says Chris Perks, CPd.

RIGHT: The illustration and the wordmark of the new logo are simpler and less ornate.

LEFT: The old packaging included the mark as part of the wine label.

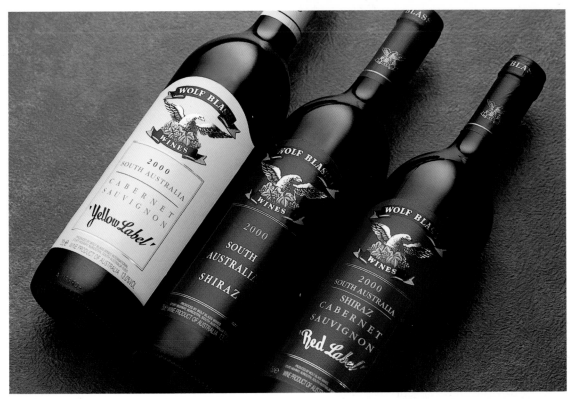

"The old identity was overtly traditional. The eagle hawk symbol, which was strongly associated with Wolf Blass, was confusing in international markets; the label was too Germanic and the eagle too American in some markets."

Designers went to work creating a new mark that would be simpler and more contemporary—both the word mark and the symbol. They kept the eagle, but modernized the image by eliminating much of the detail in the illustration. The banner, which worked as the backdrop for the Wolf Blass name, was also eliminated in favor of a clean rectangular box. "It worked on two levels—premium and super premium," says Perks. "Logotype and wordmark were more compact.

"The symbol is very flexible. The new, compact size works well in many channels. It is easier to apply across a range of different applications. Clear varietal and range color coding helps consumers differentiate between different wines," explains Perks. Previously, the mark appeared on the white label along with the varietal information. The redesigned packaging places the mark on a separate label above the wine label, making it appear to be part of the bottle.

LEFT: Wolf Blass standard range brochure for the trade, and slim brochure used for cellar door sales.

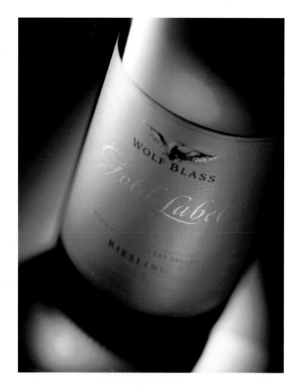

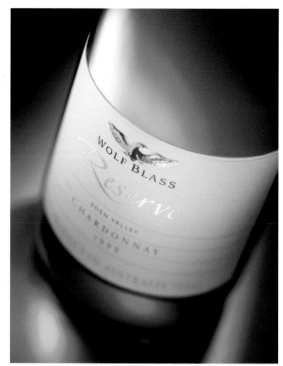

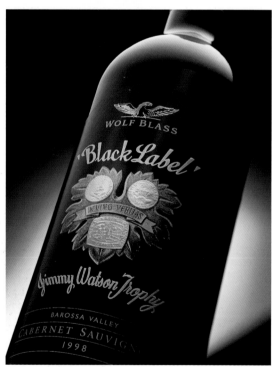

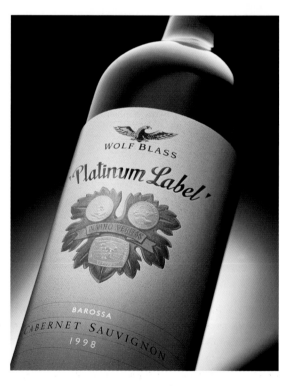

ABOVE: In addition to being simpler and easy to read, the clear varietal and range color coding helps consumers differentiate between different wines.

"The brand has been contemporized but it is still identifiably Wolf Blass—same brand that consumers know," says Perks. "Labels are simpler and easier to read. There is strong color impact. The new mark translates well across other communications material." CPd worked extensively on a variety of supporting collateral materials including developing two versions each of Wolf Blass' standard range trade brochure, premium trade brochure, and brochure used exclusively in Southeast Asia. Each brochure carries the new mark, even though at the time of printing, some of the product packaging had not yet been updated to the new look. Despite the fact that some of the product photography included the old packaging, the brochures work hard at presenting the brand as new, refreshed, and ready for the competition.

BELOW: Wolf Blass trade
brochure used in South-
east Asia, explaining the
branding levels.

RIGHT: Wolf Blass
premium trade brochure
and slim format used
for cellar door sales.

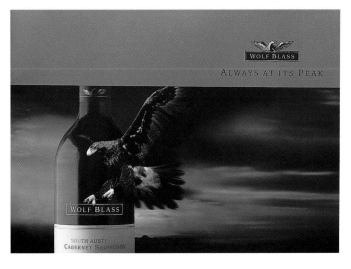

ABOVE: Brochure for
Eaglehawk, a less expen-
sive wine compared to the
standard Wolf Blass range.

RIGHT: Wolf Blass Australia
2000 Chardonnay export
label developed and sold
exclusively at the Japanese
Golden Harvest Festival.

Plenty of research went into the redesign to ensure that the new look would win
back old customers as well as lure new consumers to the brand. Designers were
happy with the results, as was the client. In particular, Wolf Blass liked the fact that
CPd was able to design with overall consistency, yet the end result managed to make
the differentiation between the ranges more obvious—a seemingly impossible task.
So happy was the client with the results, that they hired CPd to extend the identity
through brochure work for various ranges, gift packaging, environmental signage,
menu/invitations, and also assisted in developing point-of-sale materials.

What Works

"CPd's packaging and identity design has contributed to above industry level growth
for the Wolf Blass brand," says Perks. "Wolf Blass has been one of the biggest
and most successful brand relaunches in Australia and internationally." Sales are
up in Australia and overseas, where the new identity is still being launched into
virgin markets.

A Look Back

School of VISUAL ARTS:
Design That Leads Designers

DESIGN FIRM:
George Tscherny, Inc.

**ART DIRECTOR/
DESIGNER/
ILLUSTRATOR/
PHOTOGRAPHER:**
George Tscherny

ASSISTANT DESIGNER:
Matthew Cocco

CLIENT:
School of VISUAL ARTS

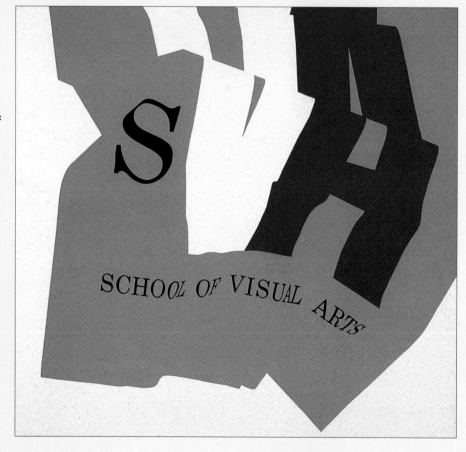

LEFT: The School of VISUAL ARTS's flag was used on as the cover photo on its 1956 catalog to commemorate the institution's name change from C & I Art School and to spotlight its newly created signature and initials, SVA.

The Process

In 1955, George Tscherny joined New York's Cartoonists & Illustrators School to teach a pilot class, with the intent of establishing a graphic design department. While the curriculum was being expanded, it was decided that the name was too limiting and in 1956, it was shortened to C & I Art School.

"A clear signal to accelerate that transition came in the form of a letter mistakenly addressed to the Seeing Eye Art School," says Tscherny. Later in 1956, the name was officially changed to School of VISUAL ARTS (SVA), and Tscherny was asked to design a logo and shorthand signature.

BELOW: Tscherny also
created SVA's annual
award to students for
Outstanding Achievement
in filmmaking, which
features the school's
logo on a piece of film.

In 1997, he was again asked to rethink the school's
visual identity, just in time to commemorate its fiftieth
anniversary.

"In the last few decades corporate marks have taken
on a hard-edge sameness," he says. "The result has
been a loss of uniqueness, which is the primary goal of
corporate identification." As a result, Tscherny avoided
the sameness he saw everywhere else. "The school's
mission is to train future generations of artists; there-
fore, it must set the trends, not follow them."

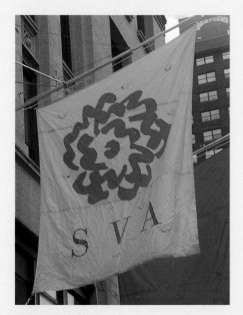

ABOVE: SVA flags hang
from its buildings at
209 East 23rd Street.

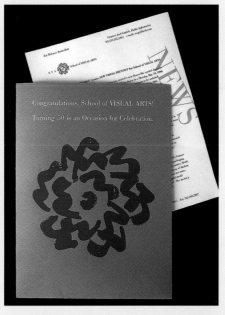

LEFT: The SVA press kit
folder and news release
paper showcases its
mark in red—as it
appears on all SVA
stationery and in
purple, which is one of
several colors that the
logo can appear in.

LEFT: SVA's logo on this
book, "From a school...to a
college, is deconstructed",
yet it retains a semblance
of the original mark.

The goal was to reflect the school's technology-based programs with its painterly
ones. "The solution contrasts the icy perfection of the computer-generated Bodoni
typeface with the spontaneity of the painterly mark."

The mark appears in red on all stationery, while tan is the color designated for all
VISUAL ARTS Foundation stationery. "Beyond that, we encourage the use of the full
color palette for the identification and image program, limited only by appropriate-
ness and budget," he says.

When silk-screened on glass, the mark reads from both sides and takes on an
ever-changing quality when seen through the diecut of the sculpture situated on
the street in front of the main building. Even deconstructed, it retains a semblance
of the original mark.

"As the school's creative director, Silas Rhodes must be credited with the high level
of posters and publications that the school is known for," says Tscherny. "While I
have always had long-standing relationships with clients, this one is unmatched in
my career, and probably in that of most other designers. I continue to implement
applications of the program to this day."

directory

Alexander Isley Inc.
9 Brookside Place
Redding, CT 06896
www.alexanderisley.com

Blok Design
822 Richmond Street West
Suite 301
Toronto, ON M6J 1C9
Canada
blokdesign@earthlink.net

Burgeff Co.
Tecualiaran 36 Vu/8
04320 Mexico D.F.
pburgeff@hotmail.com

CPd
33 Flinders Lane, 2nd Floor
Melbourne 3000
Victoria
Australia
www.cpdtotal.com.au

EAI
887 West Marietta Street, NW
Suite J-101
Atlanta, GA 30318
www.eai-atl.com

Eagle Point
4131 Westmark Drive
Dubuque, IA 52002
www.eaglepoint.com

George Tscherny, Inc.
238 East 72nd Street
New York, NY 10021
gtscherny@aol.com

Faith
26 Ann Street
Mississauga, ON
Canada
www.faith.ca

HGV
46A Rosebery Avenue
London EC1R 4RP
United Kingdom
www.hgv.co.uk

Likovni Studio D.O.O.
Dekanici 42, Kerestinec
HR-10431 Sveta Nedelja
Croatia
list@list.hr

Lippa Pearce Design
358A Richmond Road
Twickenham TM 2DLL
United Kingdom
www.lippapearce.com

Lodge Design Co.
9 Johnson Avenue
Indianapolis, IN 46219
www.lodgedesign.com

Morla Design
463 Bryant Street
San Francisco, CA 94107
www.morladesign.com

Ove Design & Communications
164 Morton Street
Toronto, ON M4S 3A8
Canada
www.ovedesign.com

Paprika Communications
400, Laurier Street West, #610
Montreal, PQ H2V 2K7
Canada
www.paprika.com

Ping Pong Design
Rochussenstraat 400
3015ZC Rotterdam
Netherlands
www.pingpongdesign.com

Riordon Design Group Inc.
131 George Street
Oakville, ON L6J 3B9
Canada
www.riordondesign.com

Rome & Gold Creative
8300 Carmel Avenue, NE
Building 6
Albuquerque, NM 87122
www.rgcreative.com

Salisbury Communications, L.L.C.
P.O. Box 2309
Venice, CA 90291
310-392-8779

Sayles Graphic Design
3701 Beaver Avenue
Des Moines, IA 50310
www.saylesdesign.com

Smart Works
113 Ferrars Street
Southbank, Victoria 3006
Australia
www.smartworks.com.au

Square One Design
560 Fifth Street NW, Suite 301
Grand Rapids, MI 49504
www.squareonedesign.com

TD2, S.C. Identity and Strategic
Design Consultants
Ibsen 43, 8th Floor
Col. Polanco C.P.
11560 Mexico D.F.
r.cordova@td2.com.mx

Trickett & Webb Limited
The Factory, 84 Marchmont Street
London WC1N 1RD
United Kingdom
www.tricketts.co.uk

Weymouth Design
332 Congress Street
6th Floor
Boston, MA 02210
www.weymouthdesign.com

Zinzell Art Direction &
Graphic Design
228 West Houston Street, #4
New York, NY 10014
www.zinzell.com

IDENTITY DESIGN THAT WORKS

Cheryl Dangel Cullen

)8

8

)

ROCKPORT